Ralph Fasanella

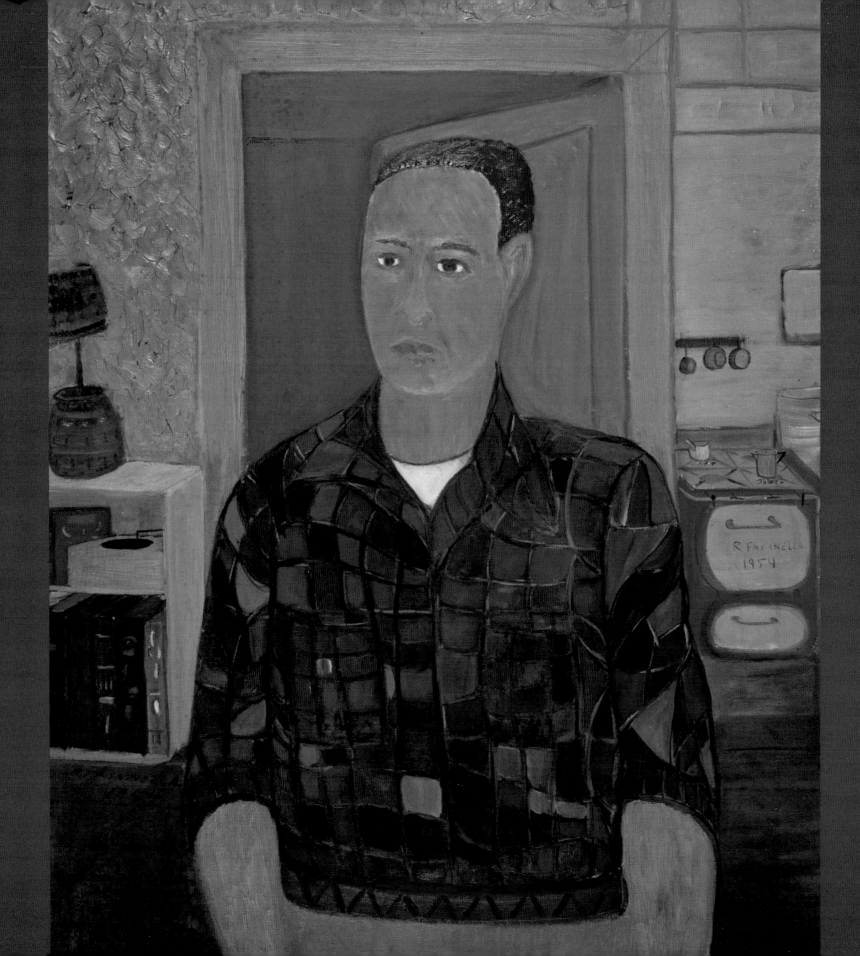

Ralph Fasanella
Images of Optimism

Marc Fasanella, PhD
Essay by Leslie Umberger
Chronology by Paul S. D'Ambrosio, PhD

Pomegranate

PORTLAND, OREGON

For Anne, whose insight, wisdom, consideration,
and encouragement made this book possible

Pomegranate Communications, Inc.
19018 NE Portal Way, Portland OR 97230
800 227 1428 www.pomegranate.com

Pomegranate Europe Ltd.
'number three', Siskin Drive
Middlemarch Business Park
Coventry CV3 4FJ, UK
+44 (0)24 7621 4461 sales@pomegranate.com

Pomegranate's mission is to invigorate, illuminate, and inspire through art.

To learn about new releases and special offers from Pomegranate, please visit
www.pomegranate.com and sign up for our e-mail newsletter. For all other queries,
see "Contact Us" on our home page.

Cover: *Old Neighborhood*, 1980. Oil on canvas, 30 x 40 in. Private collection
Frontispiece: *Self-Portrait: Grove Street*, 1954. Oil on canvas, 20 x 16 in.
Collection of Gina Mostrando

A note regarding painting dates: Ralph Fasanella often signed and dated his works
years after completion. The dates that appear in this book's captions represent the best
research available and may not match what appears on a painting.

Library of Congress Cataloging-in-Publication Data
Names: Fasanella, Marc, author.
Title: Ralph Fasanella : images of optimism / Marc Fasanella, PhD ; essay by
 Leslie Umberger ; chronology by Paul S. D'Ambrosio, PhD.
Description: Portland, Oregon : Pomegranate, 2017. | Includes index. |
 Includes bibliographical references.
Identifiers: LCCN 2016059848 | ISBN 9780764979507 (alk. paper)
Subjects: LCSH: Fasanella, Ralph. | Painters--United States--Biography.
Classification: LCC ND237.F26 F37 2017 | DDC 759.13--dc23
LC record available at https://lccn.loc.gov/2016059848

Pomegranate Item No. A266

Designed by Patrice Morris

Printed in China

26 25 24 23 22 21 20 19 18 17 10 9 8 7 6 5 4 3 2 1

Contents

Ralph Fasanella: Lest We Forget 6
Leslie Umberger

Observations from the Artist's Son 30
Marc Fasanella

 Pie in the Sky 33

 Grand Union 44

 The Iceman 52

 Love Goddess 56

 Coney Island 62

 Across the River 66

 Family Supper 72

 Dress Shop 74

 Unpacking the Mills 82

 Cabin in the Woods 92

 The Old New Neighborhood 98

 Coffee Break 106

Afterword: Being Ralph's Son 116
Marc Fasanella

Chronology 120
Paul S. D'Ambrosio

Index of Artworks 126

Acknowledgments 127

About the Authors 128

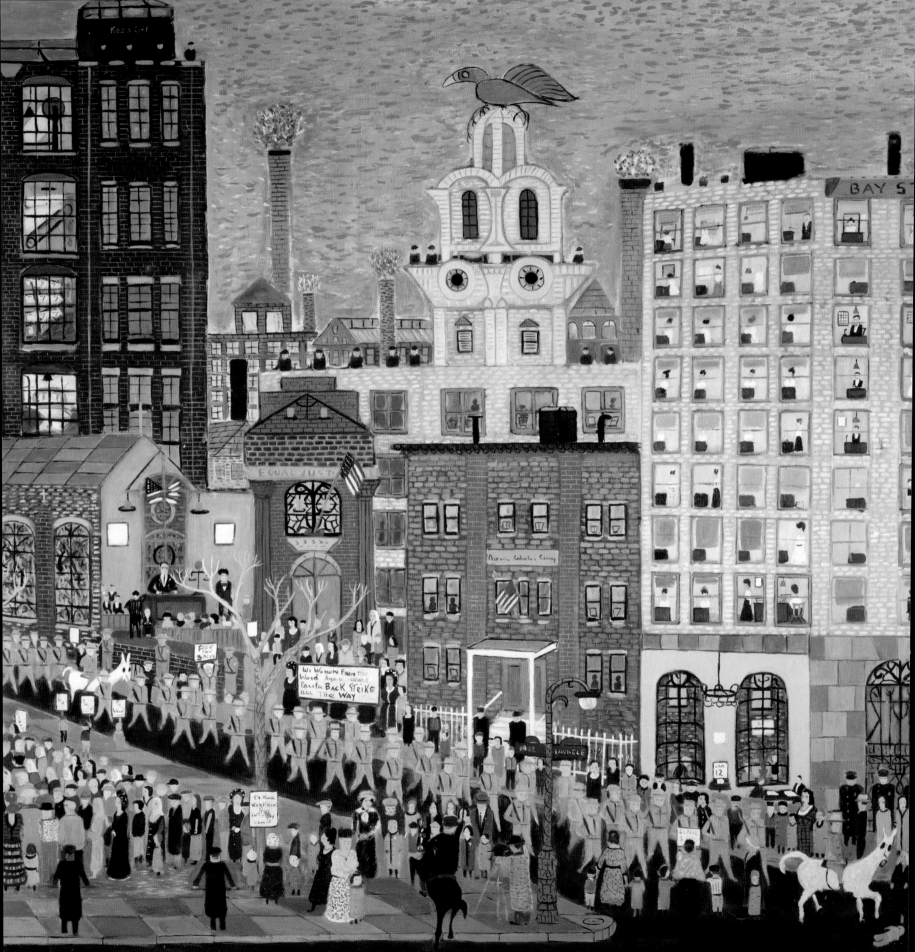

Ralph Fasanella: Lest We Forget

Leslie Umberger

Ralph Fasanella was an agent of change. He became a tireless advocate for laborers' rights, first as a union organizer and later as an artist. Fasanella took up painting when he realized that images were not passive or inert records—they were powerfully persuasive tools. From 1945 until his death in 1997, Fasanella used art as his weapon in an ongoing battle for social justice.

Fasanella was born in 1914 in the Bronx and grew up in the working-class neighborhoods of New York City. Ralph's parents, Giuseppe (Joe) and Ginevra, were among three million Italians who immigrated to America in the early twentieth century in search of a better life. They came to New York at a time of enormous social change. Capitalism was being propelled by a seemingly endless supply of cheap immigrant labor, but confrontations would escalate as the century progressed and workers ever more rapidly became rebellious unionists.

Fasanella worked as a garment worker, truck driver, ice deliveryman, union organizer, and gas station owner before he committed himself solely to painting. He had been educated only through the eighth grade and, at age thirty-one, he learned how to paint and draw much as he had learned other things in his life—through human relationships, diligent work, reading books and newspapers, and experience. Fasanella painted what he saw around him. His early works explore the rich texture of life in New York's immigrant neighborhoods: bustling tenement buildings, kids playing in the street, riders on the subway.

Fasanella's large, colorful paintings reflect the struggles of a tumultuous era. They were not meant to be rarefied works of fine art, but rather a practical means of conveying messages about right and wrong, raising consciousness, and inspiring solidarity among his working-class peers. Independently, he developed an astute, accessible, and empowering style and became known for his admonition "Lest we forget"—an impassioned plea to remember the sacrifices of our forebears. His mother had

warned him about the hazards of social amnesia; this phrase, his lifelong battle cry, was meant to strike emotional chords, targeting the bonds of family and community and the power of memory.

Early Activism

The elder Fasanellas taught their children about the costs and rewards of hard work. Joe worked as a longshoreman and later held an ice delivery route, while Ginevra raised their six children and worked in the garment industry as a sewing-machine operator. Beginning around age eight, Ralph worked alongside his father on his ice delivery route, putting in long, hard days on tough streets. Ginevra was a progressive thinker and, like many women in the needle trades, became increasingly active in promoting workers' rights. She made sure Ralph encountered people whose lives were harder than their own and taught him the value of empathy and respect. The lasting lessons he learned from his parents were that family and community came before personal gain, that younger generations stood on the shoulders of those who came before them, and that all Americans could—and should—*always* fight for their rights.

While hard work was a fact of life for tenement families, kids found fun whenever and wherever possible. Rooftops, alleyways, and the streets of the neighborhood were their playgrounds. Sometimes the boys got into trouble—stealing groceries, pocketing fruit from street vendors, or taking bikes that belonged to kids from wealthier blocks.[1] In spite of the values instilled in him by his parents, Fasanella had a rebellious streak and his antics escalated. In 1925, Fasanella was arrested for stealing items from a home and later trying to sell them. This resulted in his being sent to the New York Catholic Protectory, where orphans and juvenile delinquents were committed. While there, he chafed against the strict discipline and developed a lasting mistrust for organized religion as well as a lifelong resentment of authority.

Lawrence 1912—The Bread and Roses Strike (detail; pp. 26–27), 1977

Fasanella served three separate stints in the protectory. When he was released the last time, in 1929, life at home had changed dramatically; his childhood had evaporated. His mother had become an ardent supporter of anti-fascist causes and used their home as a meeting site. Joe's objections to his wife's increasingly strident political views and actions led to a separation, and he moved out. After the stock market crash of that year, millions were out of work or grappling with wage cuts, and the face of America was indelibly altered. Hitler's rise to power in 1933 confirmed the gravity of workers' concerns. Turmoil seemed an integral part of life for Fasanella. Activism and fighting for change had become a strategy for surviving. As he became more self-aware, Fasanella would increasingly face a personal tug-of-war between traditional and progressive values; his desire to reconcile the value of the past and his hopes for the future would define his character and shape the recurrent themes of his painting.

Fasanella got his first real job at age fifteen as an errand boy for an undergarment retailer. The Fasanella siblings all pitched in to support the household. But the jobs never seemed to last, and Fasanella increasingly felt that the capitalist system was failing Americans. Art historian and Fasanella biographer Paul D'Ambrosio noted, "Fasanella saw the Depression as a tragedy caused by greed and perpetuated by the indifference of the government and the wealthy toward the working class. Like millions of other Americans he was receptive to the exhortations of activists who sought to fight, rather than endure, the economic realities of the day."[2]

Communist party organizers made compelling arguments for working-class rights, and Fasanella was among those who believed their causes were righteous. In the early 1930s, he joined the Young Communist League and educated himself with reformist literature; he attended meetings and took to marching among the hundreds of thousands in New York's annual May Day parade. In 1937, he confronted fascism overseas by joining the Abraham Lincoln Brigade, the American contingent of volunteer regiments with the International Brigades (the group organized by Communist International), which joined the political and ideological fight against Franco's Spain. Fasanella developed leadership skills there that he would call on after his return to the United States in 1938, when he became an organizer for the newly formed Committee for Industrial Organization (CIO).

Fasanella's union activities included positions with the International Brotherhood of Teamsters in New Jersey, the Bookkeepers and Stenographers Union in New York, and the United Electrical, Radio and Machine Workers of America (UE). In 1942 he worked tirelessly to organize a major defense contractor in Brooklyn, the Sperry Gyroscope Company, a success that led to a number of other UE campaigns throughout New York.[3] In the aftermath of World War II, the nation became gripped by conservative fears, and left-leaners were accused of being "un-American." Social reformers were under attack and, in 1946, Fasanella found himself out of work.

A couple of years earlier, Fasanella had sought therapy for a painful sensation in his hands; he began sketching. He didn't take this new interest seriously until an artist he met during a summer vacation in 1945 gave him encouragement. Fasanella discovered that drawing came naturally, and he became captivated by the excitement of making images. He explored various subjects and ideas while learning the basic mechanics of painting. He was not a stranger to art, though he had never felt much enthusiasm for museums. He began going to the Whitney Museum of American Art and the Museum of Modern Art and considering the ways in which Vincent van Gogh was able to "make the paint talk."[4] He took to painting, believing from the time he began that art was an extension of his activism—not an activity of upper-class leisure or intellectualism. As an added benefit, he could distill the memories of his life through painting and attempt to strike a balance between the dichotomies of tradition and change.

An Art of Conviction

Evolving over the course of five decades, Fasanella's paintings embody their specific eras in both overt and subtle ways. After the late 1920s, artists had increasingly believed in the possibility of changing society through activism—not simply by what they said, what they stood for, or what groups they belonged to, but through their art. Artistically, Fasanella had much in common with social realist painters such as John Sloan, Ben Shahn, Robert Gwathmey, and Honoré Sharrer. Yet his work may owe a greater debt to photographers of the era, whose imagery argued for social equality in a particularly effective way. Organizations such as the Film and Photo League were, like Fasanella, strongly leftist in their sentiments, while their projects centered on improving conditions for the lower class. They sought not to affect just the art world, but the *whole* world. As photographers such as Lewis Hine, Walker Evans, and Helen Levitt bridged the worlds of journalism, the popular press, and fine art, they paved a path for fusing powerful commentary with widespread appeal, and they made the idea of art outside of the museum or gallery increasingly real.

Art historian Erika Doss has noted that interest in Fasanella's work as well as Sharrer's may have corresponded, in part, to a vogue for fifteenth-century European "primitives," Flemish painters such as Jan van Eyck and Rogier van der Weyden, and Italians such as Fra Angelico and Piero della Francesca. But, clearly, interest in Fasanella dovetailed with a rising American obsession with so-called modern primitives, or artists who seemed to capture a unique and quintessentially American spirit while simultaneously offering an antidote to the elite art world embodied in the work of the abstract expressionists. Fasanella, however, rebuked assumptions that being working class and being primitive—or any other word used to insinuate lesser intention or execution—were one and the same. His ardent belief in equality across class and education barriers may have, in the end, cost him some popularity among those who preferred to differentiate between the artistic spheres of fine and folk.

Refusing to focus on anything other than the success of his crusade, Fasanella was agreeable to enormously diverse settings for showing his paintings. He was more than comfortable putting them on view in union halls and meeting rooms, knowing that this was where his target audience would really see them. Yet he hoped to make a living from his work, too, and sought sales where he could.

In 1947 he enjoyed a solo exhibition at New York's American Contemporary Art Gallery, which was known for showing progressive work by such artists as Philip Evergood, Jacob Lawrence, and William Gropper. The painter Ad Reinhardt, who was a fellow CIO member, wrote the preface to the small exhibition catalogue and praised Fasanella for his "purpose," "playfulness," and "intensity."[5] Several additional gallery exhibitions enjoyed critical praise, yet his work failed to take off with any particular sector.

Fasanella refused to leave New York City in the post–World War II era when many city dwellers moved to the suburbs. As newly prosperous families fled the city in search of the American dream, they exchanged a close-knit life of stickball and city streets for an alienating "heaven" of swing sets and manicured lawns.

Fasanella, sobered by his experience at the Catholic protectory, believed that the promise of happiness in both heaven and the suburbs was an illusion. *Pie in the Sky* (1947; p. 36) and *Sam's Dream* (1948; p. 39) were among the paintings he made on this subject, the latter a direct response to his brother's decision to leave the Bronx for what Fasanella believed was a vapid existence in suburbia. *Pie in the Sky* drew from a popular working-class song that promised a better life in heaven. Above a depiction of New York's Lower East Side tenements—rough but vibrant—he conflated saccharine depictions of life in heaven and in the suburbs.

In 1948 he began a series exploring the unresolved feelings he had for his father; the Iceman Crucified series would encapsulate his most powerful and poignant artistic themes. His father—Joe the Iceman—is cast and recast as the crucified Christ figure to explore ideas of suffering and sacrifice, memory and personal growth. He was inspired by Pietro di Donato's novel *Christ in Concrete*, in which a bricklayer is killed at work; his sacrifices (and, by extension, those of all laborers) are related to those of Jesus. The series was a turning point for Fasanella. His artistic vision broke free from the confines of realism and his imagery became deeply personal. Fasanella explained, "It gave me the right to use symbols of people. I could make an iceman on a cross. Anything I wanted to identify with struggle I could make into Christ."[6]

Iceman Crucified #1 (1948; p. 12) is stark and visually magnetic. It confronts the viewer with a clear representation of a blue-shirted working man in a receding tenement hallway. His palms are nailed into the cross with ice picks. An oppressive pair of ice tongs displaces the crown of thorns; the tools of his trade are the devices of torture. *Iceman Crucified #3 (Passing of an Iceman)* (1956; p. 54) ruminates not on Joe Fasanella's actual death but on his retreat to Italy in 1954, a symbolic death for Ralph, who may have guessed he would never see his father again. As the artist grapples with the conflicting emotions his father inspires in him, his imagery takes flight. The neighborhood watches as the crucified iceman is lowered back to the ground, hovering over a chalk drawing in the street that reads, "'Joe' the iceman is dead. No game today."[7]

Iceman Crucified #4 (1958; p. 53) was the final work in and pinnacle of the series. In it Fasanella joins old and new worlds, marrying nostalgia and celebration. The Christ figure has emerged as a looming, heroic icon, serene and full of grace. The inscription INRI,[8] which appears above Christ in many traditional depictions of the crucifixion, is replaced with the phrase that came to be equated with the artist himself: "Lest we forget"—a clear message to remember who we are and where we come from.

Fasanella married Eva Lazorek in 1950. This decade saw Fasanella's work increase in scale and complexity, and the paintings he made were among his strongest. He became adept at fusing his memories and personal experiences with the social and political messages he wanted to impart. The era was fraught with Cold War tensions, and Fasanella was consumed by powerful current events. In 1951, Ethel and Julius Rosenberg were convicted of conspiracy to commit espionage, although

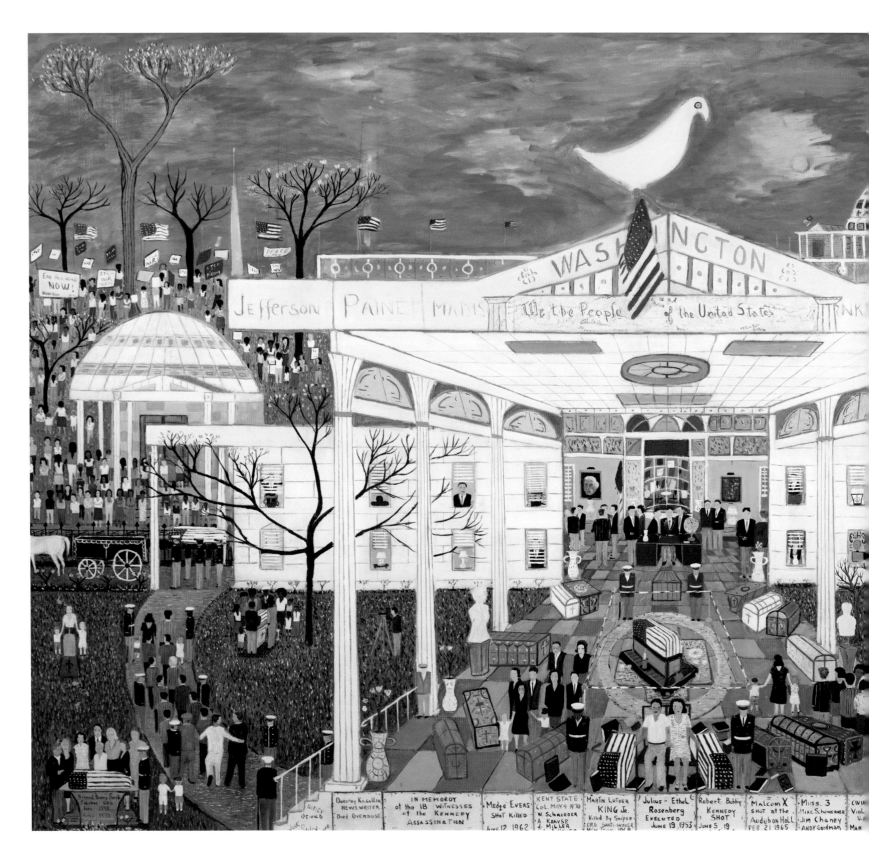

American Heritage, 1974. Oil on canvas, 50 x 80 in. American Folk Art Museum, New York.
Gift of Eva Fasanella and her children, Gina Mostrando and Marc Fasanella, 2005.5.1.

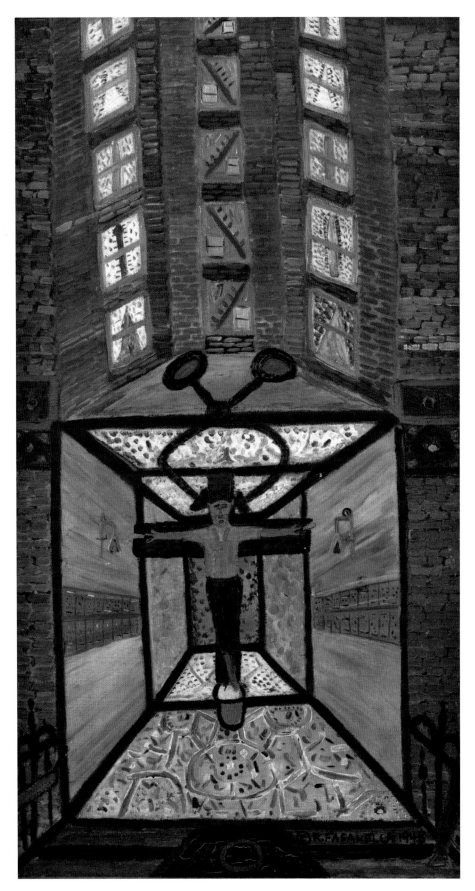

Iceman Crucified #1, 1948. Oil on canvas, 26 x 14 in.
Private collection. Courtesy Andrew Edlin Gallery

many Americans doubted their guilt. They were put to death by electric chair in 1953, becoming the only American civilians to be executed for espionage-related activity during the Cold War.

Fasanella was among the strident believers convinced that the FBI had made scapegoats of the couple in an attempt to flush out other left-leaning activists, but the Rosenbergs never named anyone else in their testimony. *Garden Party* (1954; p. 14) confronts what Fasanella felt was a wrongful death; it would be the first of many paintings in which he used the couple as symbols of injustice and protest.

Wisconsin Senator Joseph McCarthy's aggressive pursuit of communists trampled individual rights; many of those accused of being anti-American lost their jobs or had their livelihoods sabotaged. Artists, actors, writers, and musicians were among the most highly persecuted; the Hollywood blacklist first appeared in the *Hollywood Reporter* in 1946 and named known or suspected Communist agents and sympathizers—who immediately became unemployable. In his 1953 play, *The Crucible*, Arthur Miller allegorically equated McCarthyism and the Red Scare hysteria with the infamous 1692 witch trials and executions in Salem, Massachusetts. Fasanella joined with Miller when he depicted the Rosenbergs side by side in a fiery pit. Taking a satirical tone, Fasanella situates the scene against the dome of the US Capitol—an icon of democracy and freedom—while those protesting and celebrating the conviction clash at the fore.

Amid the tensions of the Cold War, Fasanella was blacklisted for his leftist leanings. For some years he had been envisioning an epic work that brought the pulse of his beloved home city to life. *New York City* (1957; pp. 50–51) is a monumental celebration of Fasanella's city—its cadence, culture, architecture, and people. Queens and Long Island mark the horizon, as the Queensboro Bridge brings the viewer into the teeming heart of the city. Fasanella based the foreground on the uptown neighborhood where he lived at the time, condensing a roughly one-hundred-block area along Broadway between Fifty-Ninth and 155th Streets. By distorting scale to suit his needs and taking inspiration from the heightened perspectives of Brooklyn's elevated subways, Fasanella was able to capture both skyline and street scene. This painting was an attempt to sidestep overt political subjects, yet the artist still characteristically captured and celebrated the spirit of the masses.

In the late 1950s, support for McCarthyism waned. High courts began to reverse the false convictions, and the anxieties associated with expressing liberal opinions became less acute. Fasanella responded to the easing of tensions by addressing subjects still weighing on his mind

and began to explore civil rights issues and the increasingly strong counterculture movement.

Fasanella still carried resentment from the Cold War era and he sounded a rallying cry with two works: *The Rosenbergs' Gray Day* (1963; pp. 16–17) and *McCarthy Press* (1963; p. 18). His goal was not to make martyrs out of the Rosenbergs, but rather to illuminate the injustice of their deaths. Laden with symbolism and dark imagery, both paintings are dominated by a large, central letter *A*, a reference to the atomic bomb and the intense paranoia that dominated the era. Each letter is crowned with a devilish totem—an ominous specter, looming large. In *Gray Day*, the Rosenbergs sit together awaiting their horrific ordeal: death by electric chair. Their children play nearby, while coldhearted officials seal their fates. *McCarthy Press* is an even darker composition, set after the execution. A crane lowers one of the Rosenbergs' coffins to the ground, while icons of democracy loom against a bloodred sky.

Only months after Fasanella completed his works on the Rosenbergs, President John F. Kennedy was assassinated in Dallas, Texas. Fasanella became obsessed with the news coverage and believed conservative forces were responsible. *American Tragedy* (1964; pp. 20–21) situates Kennedy against a symbolic backdrop that amalgamates the American civil rights movement and the capitalist industrialization of the South.

This complex composition charts Fasanella's views about the assassination and its ties to the moral and economic underpinnings of American political and social mores. The left and lower-right sections of the canvas portray symbolic civil rights events, including the March on Washington and the Birmingham riots. Central to the image is a figure fusing the tropes of businessman, cowboy, Klansman, and southern gentleman—inspired by both conservative senator Barry Goldwater and Vice President Lyndon B. Johnson, who assumed presidential office after Kennedy's death. The power-hungry figure rides roughshod over Kennedy's casket, while an adjacent scene shows Kennedy and his motorcade heading into an ominous tunnel. "I caught the painting. Right away I called it *The Tunnel of Lies*. I had Kennedy going into the tunnel and the American Legion and Goldwater coming out of it," the painter explained.[9]

In the mid-1960s, Fasanella's life underwent significant changes. In response to the needs of their growing family, the Fasanellas moved to Ardsley, New York.[10] A few years earlier, the family had moved from Manhattan to the Bronx, where Fasanella had become the co-owner of a gas station. He had been reluctant to leave Manhattan, but Eva was resolute. The 1964 move to the suburbs meant a commute to the gas

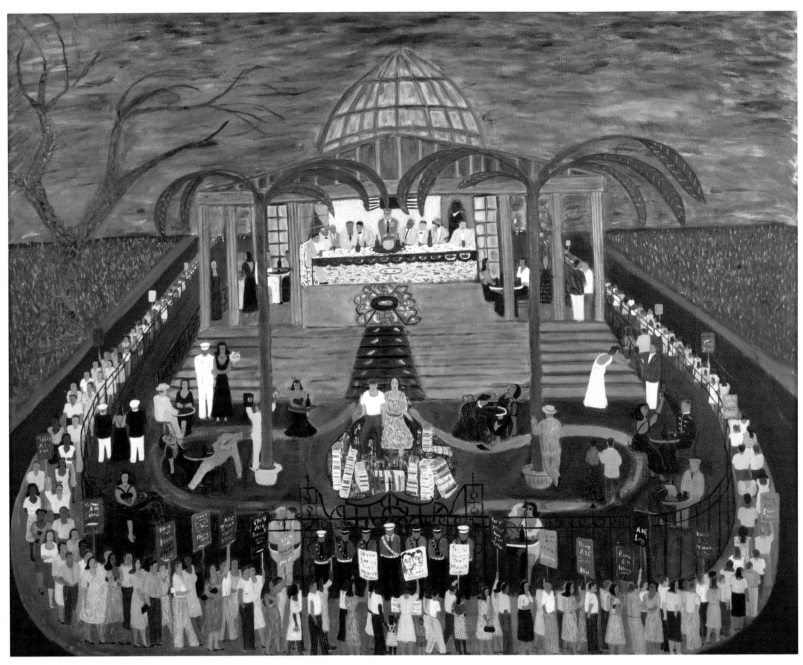

Garden Party, 1954. Oil on canvas, 40 x 50 in. Courtesy Andrew Edlin Gallery

station, and the departure from the city thwarted the artist's creativity for a time.

Fasanella had found the zeitgeist of the civil rights era vital and inspiring; the unity of nonviolent protest and civil resistance fused ideals he had spent his life advocating. But as the antiestablishment counterculture movement grew increasingly visible and vociferous, tensions increased between Fasanella's generation and younger Americans, who had different ideas about what composed the American dream. By 1965, statistics showed that half the population was under the age of twenty-five.[11] Society changed rapidly in response to youthful taste and demands, fueled by the meteoric rise of television and the popular press. Fasanella's views typified those on the older end of the generation gap, for whom the shared hardships of the Depression and World War II were indelible. He found the attitudes, assumptions, and actions of the baby boomers, known for defying convention, to be ungrateful, arrogant, and self-centered.

Fasanella became increasingly disheartened by the actions of the counterculture, but his objections drove him again to make powerful images. A 1966 painting titled *Modern Times* proposes a futuristic urban scene in which an impersonal and technological society has displaced traditions of compassion and community. Fasanella completed this work following Pope Paul VI's 1965 visit to Yankee Stadium, and it employs the iconography of baseball to symbolize America's secular religion—for him a more honest and unifying instrument for social cohesion than sectarian religion. In this painting he contrasts humanistic subjects such as the papal visit and images of workers, protesters, strikers, and returning soldiers with the detached, intellectual side of society—the worlds of science, technology, and fine arts. Fasanella felt the elitist art world had pigeonholed him as "primitive and stupid." He ardently believed that art didn't have to be aloof or conceptual; it was a tool to be wielded like a hammer.

This idea may have been inspired, at least in part, by the legendary folk singer Pete Seeger, who first publicly performed his famous song "If I Had a Hammer" in 1949 in New York at a testimonial dinner for leaders of the Communist Party of America and, like fellow folk singer Woody Guthrie (who had emblazoned his guitar with the words "This machine kills fascists"), had become widely known for using his art as a weapon. Seeger, like Fasanella, would be blacklisted for his Communist ties, and he was later convicted for contempt of Congress when he refused to name his associations or answer questions that violated his civil rights. But Seeger became legendary for his style of gentle rebellion and his savvy ways of reaching the masses through simple, strong, and direct songs meant not as testaments of personal artistry or skill but as tools of unity. A closer parallel to Fasanella's way of thinking about his art may not exist, and indeed the two men became good friends.[12]

Around this time, Fasanella began to think about issues more broadly than he had earlier, and he set about making images with themes that were less specific and more overarching. He also began to call upon stories told to him by his mother. In a powerful work from 1972, *Family Supper* (p. 73), he touches once again on the Iceman series, but this time the central figure is Ginevra; this work is both a personal tribute to her and an account of the matriarch's inestimable sacrifices.

Seated at the center of a table reminiscent of the scene in Leonardo da Vinci's *The Last Supper*, Ginevra, a maternal icon, looks at us with tired eyes that express the cumulative exhaustion of child rearing, housekeeping, and laboring in the garment industry. Her family surrounds her, and the table is laid with food common in Italian American homes. At the right appears a nod to the sacrifices of Joe Fasanella, again as the crucified Iceman, but Ginevra herself is crucified in the center of the image, symbolizing the great endurance her life has required.

The top of her cross bears the initials WHS, for "We have suffered," and Fasanella's recurring admonition, "Lest we forget," appears on the building's pediment. A palette of bright colors draws viewers into a scene where every bit of imagery holds symbolic detail. The painting offers a powerful crossroads of themes: family, struggle, endurance, gratitude.

The tide finally turned for Fasanella in the early 1970s, after twenty-five years of showing his paintings in union halls, churches, and various small venues. He caught the attention of folk art scholar Frederick Fried, who helped Fasanella get a promotional agent who, in turn, set about making Fasanella known. The artist soon became a phenomenon in New York, appearing on the cover of *New York* magazine in 1972, with the headline "This man pumps gas in the Bronx for a living. He may also be the best primitive painter since Grandma Moses."[13] The article and a simultaneous exhibition at the American Foundation on Automation and Employment (Automation House) resulted in a period of fantastic success; the transition from obscurity to celebrity was instantaneous.

Fasanella sold the gas station and turned to painting—as well as the various demands of success—full-time. In 1973 he was given a solo exhibition at the Xerox Corporation's Exhibit Center in Rochester; the forty-seven paintings shown there attested to Fasanella's enduring vision, and the first biography of the artist was published that same year by Alfred A. Knopf.[14] The book fueled further acclaim

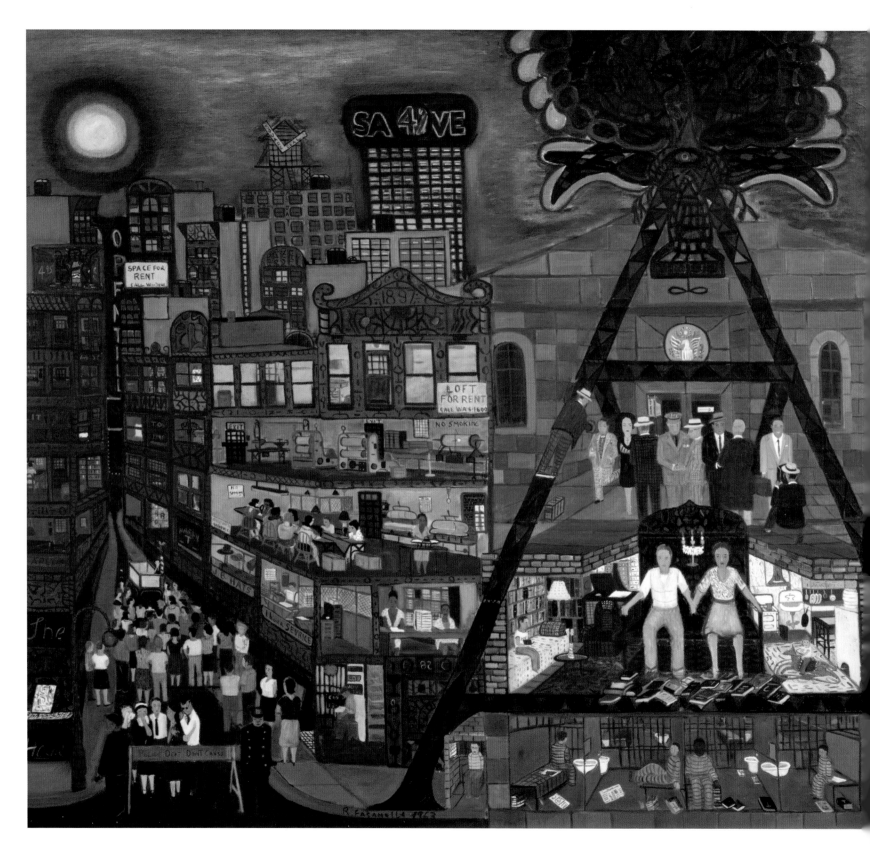

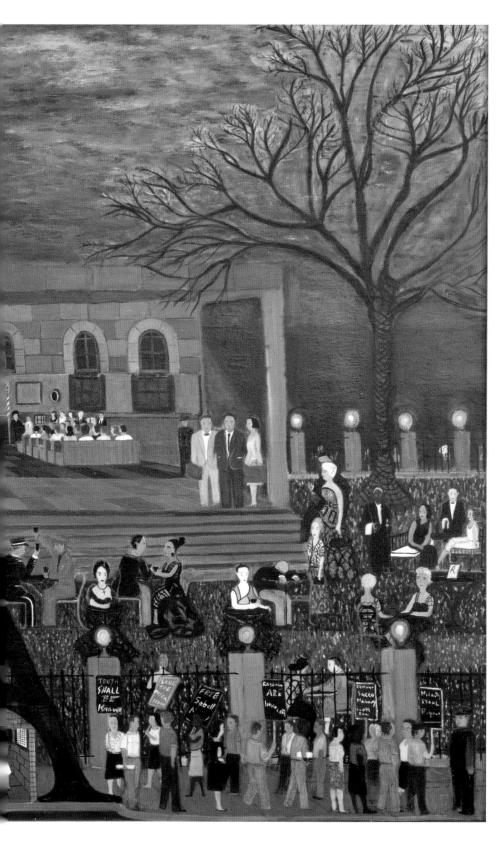

The Rosenbergs' Gray Day, 1963. Oil on canvas, 42 x 72 in.
Courtesy Andrew Edlin Gallery

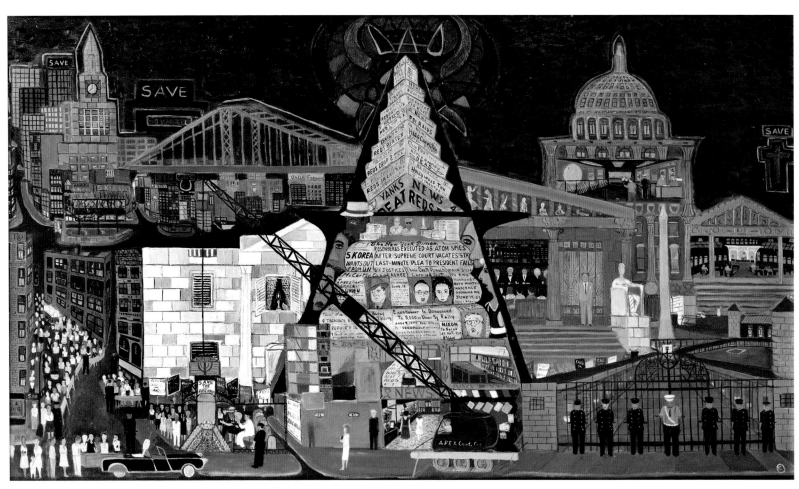

McCarthy Press, 1963. Oil on canvas, 40 x 70 in. American Folk Art Museum, New York.
Gift of Eva Fasanella and her children, Gina Mostrando and Marc Fasanella, 2005.5.6

for Fasanella and prompted an exhibition at the Coe Kerr Gallery on East Eighty-Second Street, known for its stable of successful artists, including Andrew Wyeth. West Coast art critic Alfred Frankenstein wrote an introduction to the catalogue that distinguished Fasanella from other so-called folk artists in a number of ways, arguing that he was—although untrained—an artist who had devoted decades of toil to a developing creative vision.

Within a couple years, however, the celebrity faded. The Nixon presidency and life in the suburbs were subjects Fasanella explored, but with limited zeal. Looking for a large, meaningful project on which to focus, Fasanella began to think about how he could historicize and keep alive the monumental efforts of the working class in the first half of the twentieth century.

In 1975, Fasanella focused on the historic 1912 Bread and Roses strike in Lawrence, Massachusetts. In this two-month battle, twenty thousand immigrant workers challenged textile mill owners over fair pay and working conditions; their strike changed the course of American labor rights. Fasanella lived part-time in Lawrence for three years, reading, sketching, and talking to the surviving strikers and their families. He studied the mill machinery at the Merrimack Valley Textile Museum, making detailed sketches and notes. Fasanella's research and his efforts to connect living family members with the documented efforts of their forebears made a tremendous and lasting impact on the community, and his project culminated in a series of eighteen major paintings. Throughout the series, his imagery is confrontational and resolute, the themes of organized resistance and martyrdom ever present.

In 1978, Fasanella's series on the strike went on view at the Lawrence Public Library and was viewed by thousands. D'Ambrosio underscored the lasting importance of these works:

> In pursuing and executing the Lawrence paintings as a grand historical epic Fasanella acknowledged one of the most traditional tenets of art history—the primacy of history painting—while challenging the canon of American history. His contribution to history painting in the 1970s can best be judged in the context of the revisionist social history of that time. Although he acknowledged the traditional notion of history painting as the noblest artistic pursuit, he challenged the pictorial conventions of historical art and provoked the historical canon to include working-class and immigrant heritage.[15]

The Lawrence series brought Fasanella enduring acclaim. In the 1980s and 1990s, he largely painted scenes that refined familiar subjects, such as urban neighborhoods, baseball, and labor strikes. His wife organized a major exhibition of his work in 1985 that succeeded in bringing his art to museum audiences. As Fasanella's declining health compromised his ability to execute the large-scale works that had once consumed him, he worked with labor organizer Ron Carver to increase the public exposure of his work through the Public Domain project, a grassroots campaign initiated in 1988 with the aim of purchasing works out of private collections and donating them to institutions or municipalities.[16]

Through Carver's passion and dedication, some of Fasanella's most important works became available to the audience that meant the most to the artist—the American public. Carver's model entailed identifying communities and institutions where certain paintings would have significant influence. He subsequently worked with institution leaders, teachers, and other local community members to raise awareness, enthusiasm, and financial support. Carver was a compelling advocate, and the project's board members included such notable public figures as Ed Asner, Ossie Davis, Ronnie Gilbert, Doris Kearns Goodwin, Olga Hirshhorn, Eleanor Holmes Norton, Pete Seeger (who would later sing at Fasanella's memorial service), and Studs Terkel. Public Domain would place more than twenty major works in public collections. Among their major successes were two acquisitions: *Lawrence 1912—The Bread and Roses Strike* (1977; pp. 26–27) for the Lawrence Heritage State Park Visitor's Center, and *Family Supper*, which was donated to the Ellis Island Immigration Museum in 1991.

In 2013 Erika Doss wrote, "Fasanella believed that a nation founded on aspirations of liberty, freedom, and collective social progress should, in fact, live up to those ambitions; similarly, he didn't sugarcoat how the nation had in his opinion seemingly failed, or fallen behind."[17] Certainly Fasanella had a knack for cutting straight to the heart of any injustice in his images. His paintings function as memorial tributes, didactic tools, and rallying cries; they make palpable his vision of a better society. Though Fasanella was not born on Labor Day, he celebrated that date as his birthday, proud to align his own life with the identities and histories of the working class. The era that shaped Fasanella and the work that he, in turn, produced may similarly inspire younger generations to look to the past for models, to take inspiration from those who went before us and proved, time and again, that the common folk have real power when they subvert complacency and act collectively.

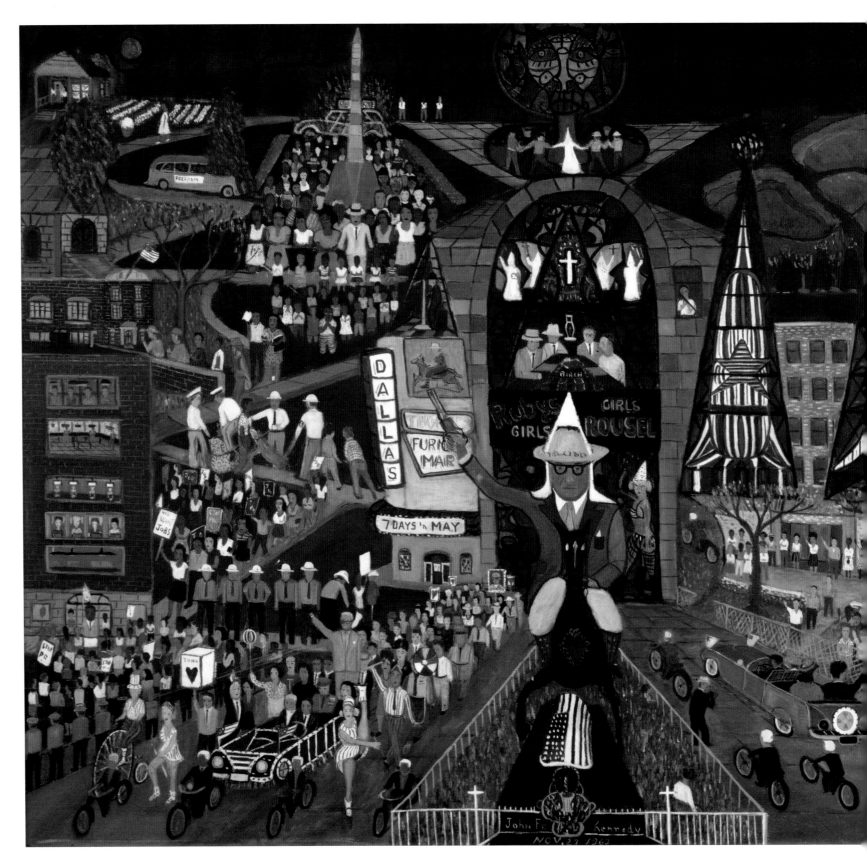

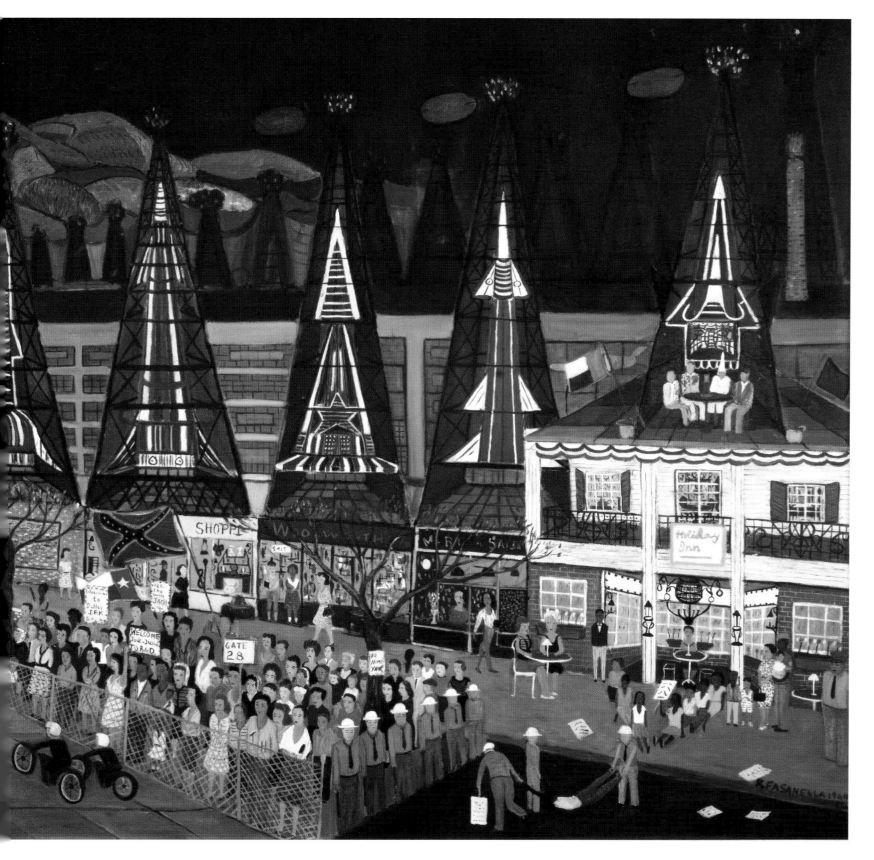

Previous spread: American Tragedy, 1964. Oil on canvas, 42 x 90 in.
Private collection. Courtesy Andrew Edlin Gallery

Watergate, 1976. Oil on canvas, 60 x 90 in. American Folk Art Museum, New York.
Gift of Eva Fasanella and her children, Gina Mostrando and Marc Fasanella, 2005.5.5

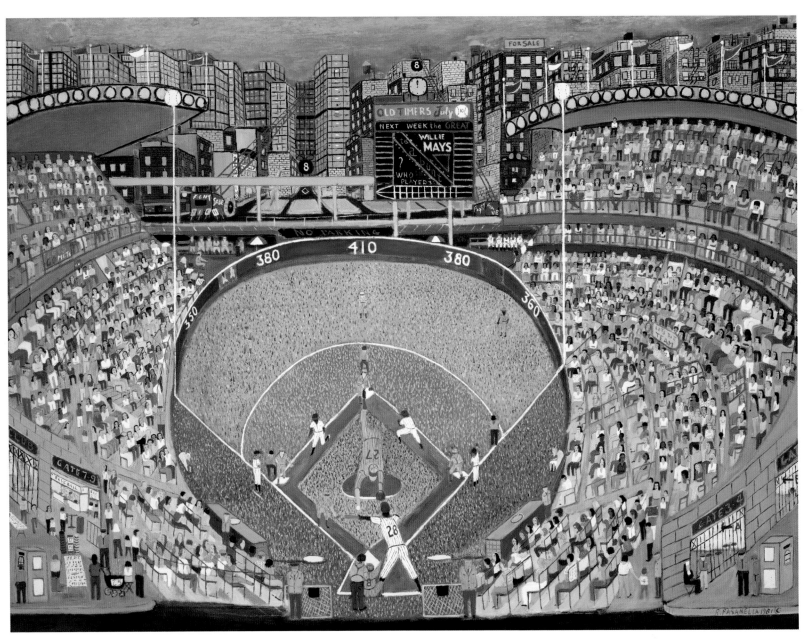

Night Game—'Tis a Bunt, 1981. Oil on canvas, 46 x 60 in. Private collection. Courtesy Andrew Edlin Gallery

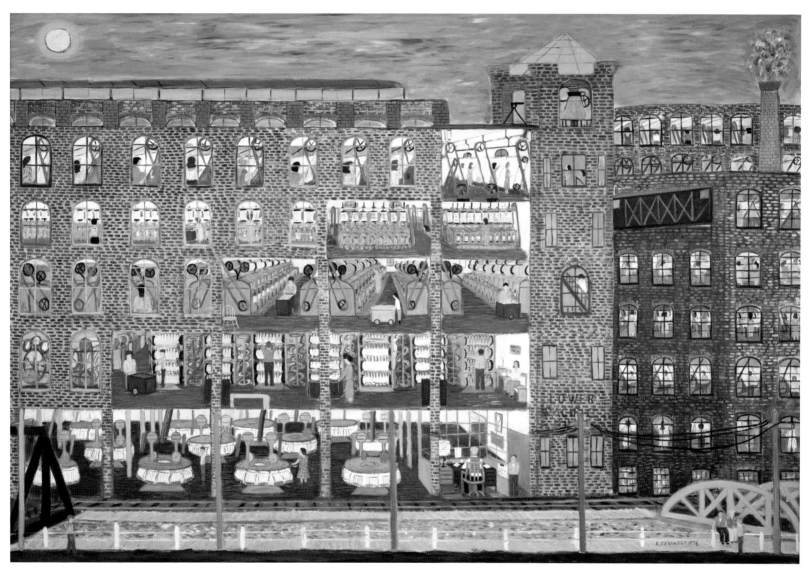

Mill Workers—Night Shift #1, 1976. Oil on canvas, 45 x 66¼ in. Hirshhorn Museum and Sculpture Garden, Smithsonian Institution, Washington, DC. Gift of Joseph H. Hirshhorn, 1977, 77.24

Following spread: *Lawrence 1912—The Bread and Roses Strike*, 1977. Oil on canvas, 45 x 90 in. Lawrence Heritage State Park, Department of Environmental Management, Commonwealth of Massachusetts, and the City of Lawrence, Massachusetts

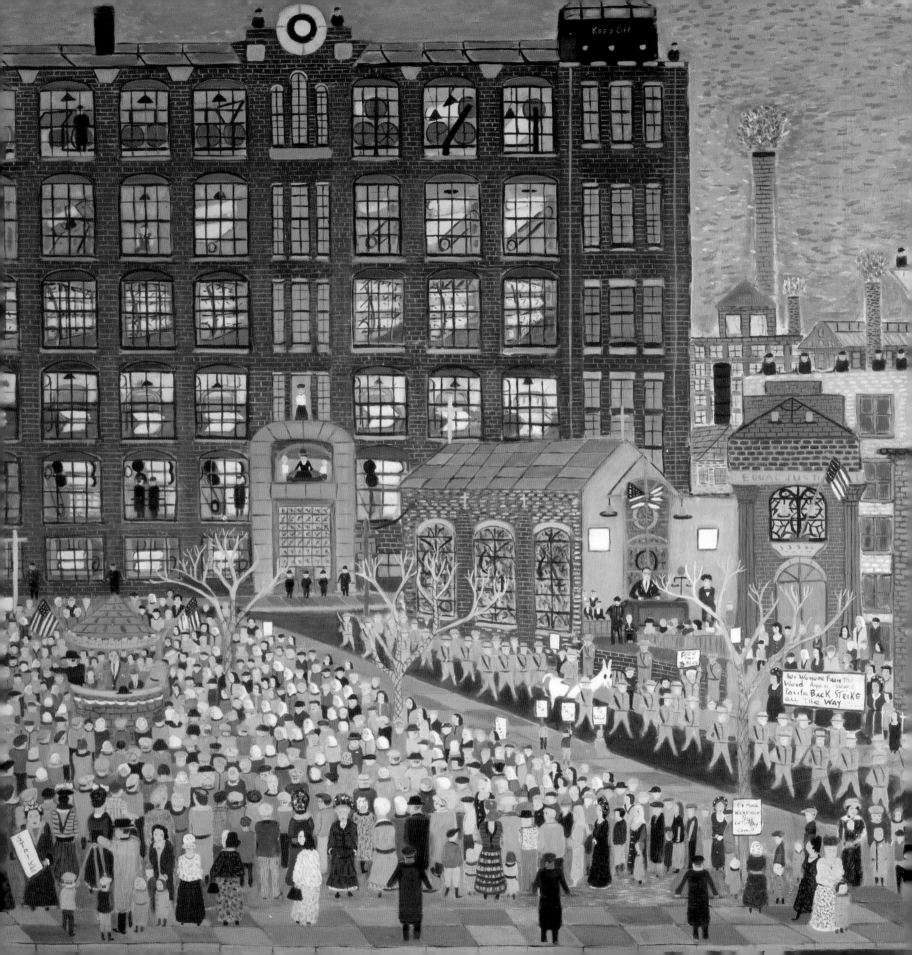

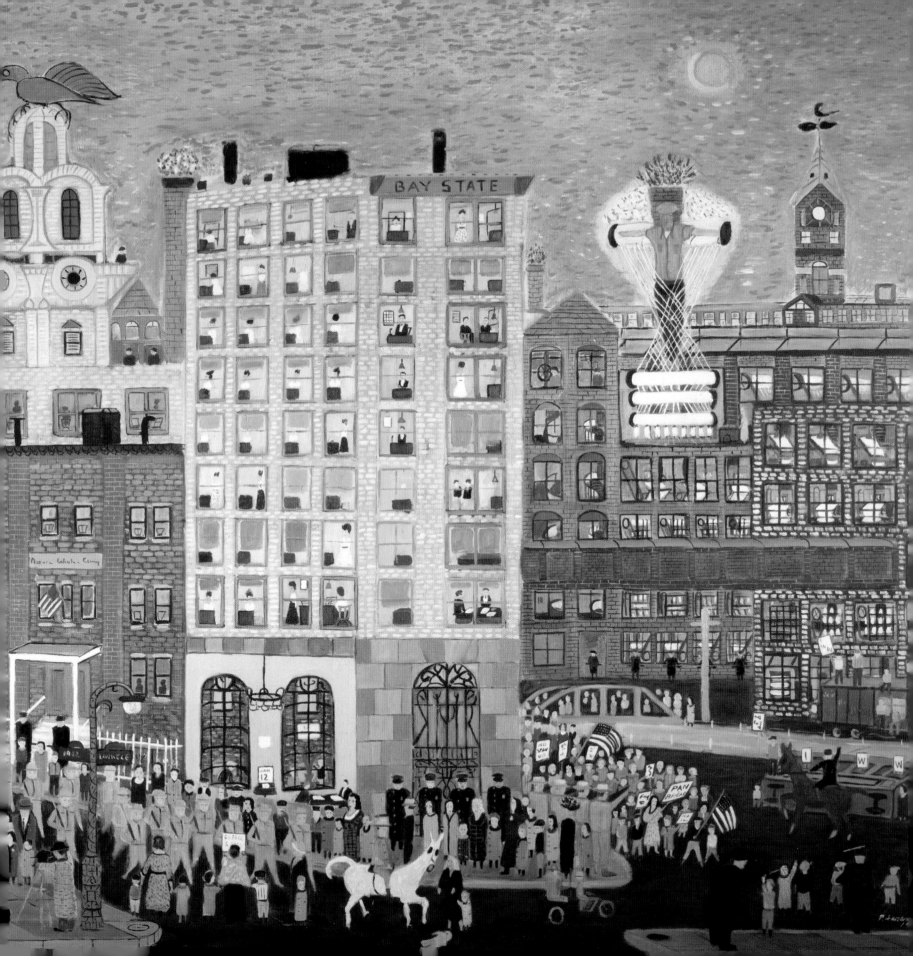

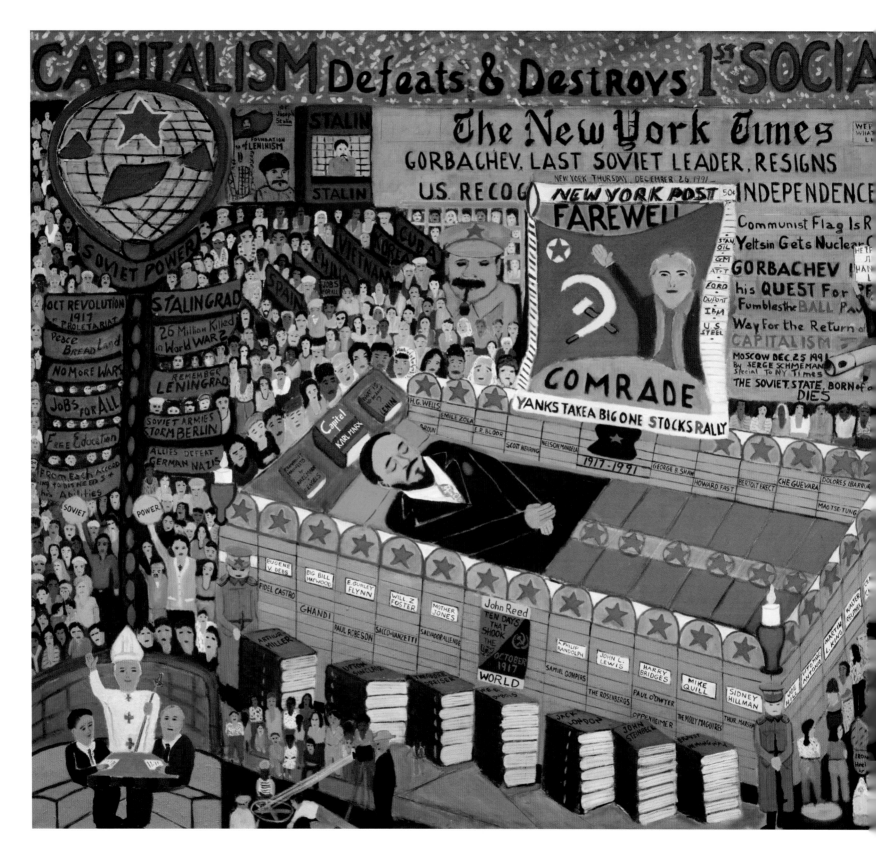

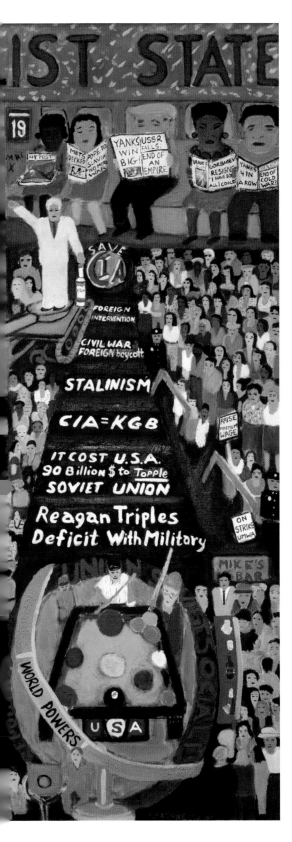

Notes

1 Paul S. D'Ambrosio, *Ralph Fasanella's America* (Cooperstown, New York: Fenimore Art Museum, 2001), 22–23, published in conjunction with the exhibition of the same name, shown at the Fenimore Art Museum, the New-York Historical Society, and the Mennello Museum of American Folk Art. This essay owes inestimably to D'Ambrosio's in-depth research on Fasanella and this history of the artist's life and work.

2 D'Ambrosio, *Ralph Fasanella's America*, 28.

3 Erika Doss, "Ralph Fasanella's More Perfect Union: Art, Labor, and Politics in Post–World War II America," in *Ralph Fasanella: A More Perfect Union* (New York: Andrew Edlin Gallery, 2013), 7, published in conjunction with the exhibition of the same name, shown at Andrew Edlin Gallery.

4 D'Ambrosio, *Ralph Fasanella's America*, 44.

5 As quoted in D'Ambrosio, *Ralph Fasanella's America*, 60.

6 As quoted in D'Ambrosio, *Ralph Fasanella's America*, 56.

7 D'Ambrosio, *Ralph Fasanella's America*, 76. D'Ambrosio has surmised that Fasanella may have added this inscription after Joe Fasanella died in 1961, since he was still living at the time this painting was made. It is also possible, however, that the inscription, for Ralph, was symbolic and made in response to his father's return to Italy, a relinquishment of his immigrant's dream of a better life in America.

8 The acronym *INRI* stands for the Latin translation of "Jesus of Nazareth, King of the Jews."

9 Patrick Watson, *Fasanella's City: The Paintings of Ralph Fasanella with the Story of His Life and Art* (New York: Ballantine Books, 1974), 120–125. The painting was retitled *American Tragedy* upon its completion.

10 Daughter, Gina, was born in 1958; son, Marcantonio (Marc), was born in 1964.

11 David Farber, *The Sixties Chronicle* (Lincolnwood, Illinois: Legacy Publishing, 2004), 16.

12 According to the artist's friend Ron Carver and his son, Marc Fasanella, the friendship of Ralph Fasanella and Pete Seeger can be reliably dated to 1966, the year of the first Clearwater Festival, which Ralph and Eva would thereafter attend annually. It is likely, however, that it began as early as the late 1940s, when the folk group the Weavers began performing in Greenwich Village. Fasanella was known to be friends with Ronnie Gilbert, a member of the group, as was Seeger. Ron Carver and Marc Fasanella, in conversations with the author, March 28, 2014.

13 Nicholas Pileggi, "Portrait of the Artist as a Garage Attendant in the Bronx," *New York*, October 30, 1972, cover and 37–45.

14 Patrick Watson, *Fasanella's City: The Painting of Ralph Fasanella with the Story of His Life and Art* (New York: Alfred A. Knopf, 1973).

15 D'Ambrosio, *Ralph Fasanella's America*, 128.

16 Ron Carver, "The Public Domain Story," Smithsonian American Art Museum, 2014, http://americanart.si.edu/exhibitions/online/fasanella/Fasanella_Carver.pdf.

17 Doss, "Ralph Fasanella's More Perfect Union," 5.

Farewell, Comrade—The End of the Cold War (center panel of triptych), 1992–1997. Oil on canvas, 60 x 88½ in. American Folk Art Museum, New York. Gift of Eva Fasanella and her children, Gina Mostrando and Marc Fasanella, 2005.5.3

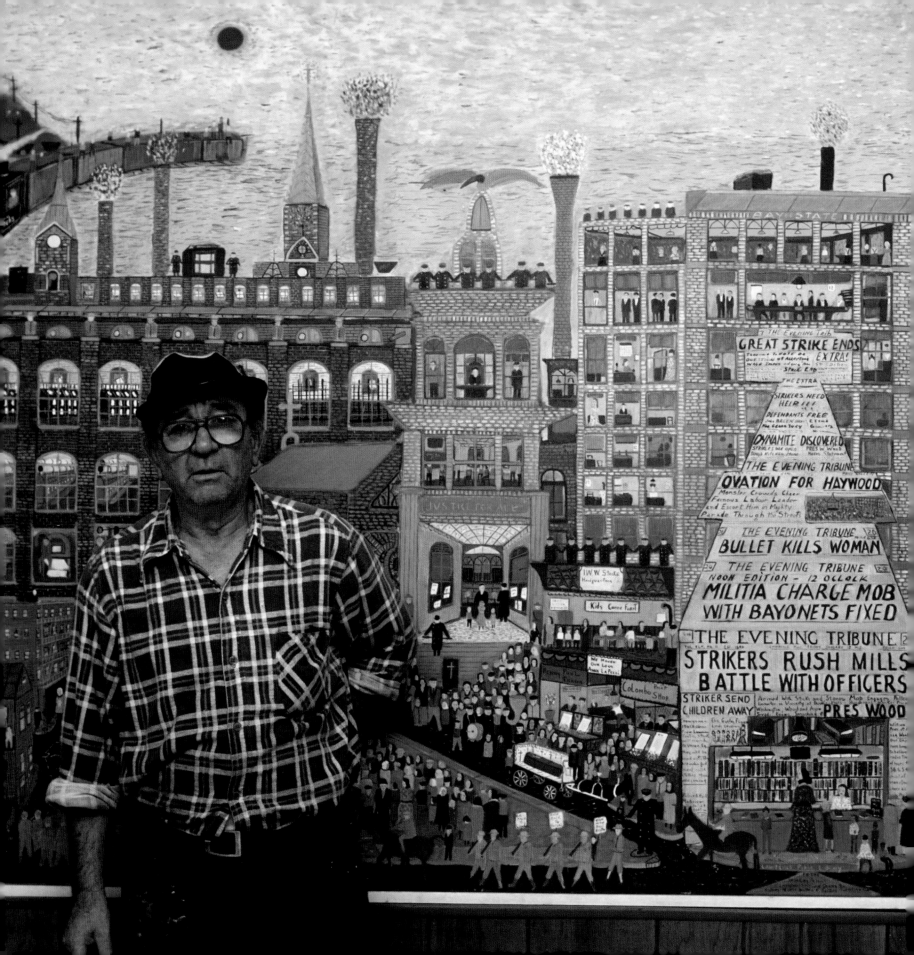

Observations from the Artist's Son

Marc Fasanella

I believe my father will be remembered foremost for his large political canvases. He chronicled many of the seminal events of his lifetime: the struggle for a living wage and an eight-hour workday, the Cold War, the execution of Julius and Ethel Rosenberg, the assassination of John F. Kennedy, the sexual revolution of the 1960s, Watergate, and the collapse of the Soviet Union. As a self-taught painter, he created imagery in an articulate, sophisticated, inventive, and unique way. He was constantly trying to master the mathematical perspective discovered by Renaissance painters, and, as a result, his best canvases have several perspectives and modes of scale, creatively unified through the application of sophisticated color choice, texture, and visual metaphor. His work was informed by an extraordinary combination of outwardly working-class, straightforward simplicity and inwardly deep intellect. I once thought his political canvases were his only important work, but now I have come to think otherwise.

As a young adult, Ralph tried to follow in his father's footsteps as an iceman. He also worked as a truck driver, a volunteer in the Spanish Civil War with the Abraham Lincoln Brigade, a machinist's apprentice, a union organizer, and a gas station owner. These experiences accorded him worldliness, as well as the basic knowledge of how to use his hands and converse with nearly anyone, which I found impressive as a kid. But to me, my father was first and foremost a painter. I was born when he was fifty; by the time I turned fourteen he had already sold his gas station and devoted himself full-time to painting.

I came of age at a time when my father was truly able to pursue his creative muse. He would spend some days engrossed in deep intellectual conversation with a friend; others in search of inspiration at diners, union halls, or just "out in the world"; and many in the impassioned pursuit of a completed painting. I loved to watch him work. In his home-based studio, he kept a small bed, where I often read, daydreamed, or napped.

He played his 78 and LP jazz and opera records on a powerful but ancient audio system, and I loved that music. By the time I reached college, I used his old drafting table as a place where I could spread out my work in progress and ponder it a bit. When I became an accomplished carpenter, he enlisted me in manifesting the perpetual evolution of his studio. I built shelving, installed a new audio system, and helped him organize his extensive collections of books, records, and ephemera. He collected visual references for all his paintings. When he was between working on one series and another, he would reorganize the wide-ranging collage of images that covered the walls and surfaces around him as he painted.

My father read widely and collected books on politics and art. He was conversant in nineteenth-century political theory, had an in-depth knowledge of all the French impressionists, and was a devotee of Van Gogh. You can see that influence in the way he depicted skies and modeled the surfaces of buildings. His early work, before he had logged countless hours in libraries, museums, and his studio, features incredibly thick paint overall, but his mature work reflects the impressionists' impasto, where moderately thick strokes are used for aesthetic reasons. He was also a profound admirer of the late eighteenth-century painter Francisco de Goya and Mexican social realist Diego Rivera, whose influence is easily seen in my father's most dynamic political paintings.

My father's duality as a working-class family man and an intellectual has pervaded my own identity and caused me quite a bit of existential angst over the years. I have pursued a career as an academic but have always worked with my hands and have approached life from a class perspective. I didn't feel fully comfortable in my skin until my midforties, when I finally came to understand the value in being able to empathize equally from working-class, street-smart, and academically sound perspectives. I now have great insight into the turmoil that compelled my father to paint.

Ralph Fasanella with *The Great Strike (IWW Textile Strike)*

From my earliest recollection, my father treated me as an equal. To him I was a guy to knock around with, exploring the world, discussing politics, and appreciating life. On his days off when I was young, he would take me to his gas station, to the Fulton Fish Market, to his sister's apartment for delicious meals and conversation, and to the textile mills in Lawrence, Massachusetts. The two of us often ate together, played cards, or simply hung out. We shared no special rituals, but he was profoundly present as a father every moment I was with him. As I got older, he always asked my opinion on important matters perplexing him and took my suggestions at full value. When he had to admonish me in some way, he would appeal to my reason and often end with "you're smarter than that, old man." Of course, there were times we heatedly disagreed, but even if he threw a string of expletives at me, I knew they were propelled by love. As I exited adolescence, I began to address both of my parents by versions of their first names, Eva and Ralphie, an indication of our genuine friendship above and beyond our familial roles.

My father's shoes were awfully large to fill, and I never tried. When I studied art, architecture, and design in college I picked up a brush a few times, but I could tell I didn't feel the passion for that form of communication in the way my father did. He didn't "know" how to paint. He painted because he was compelled to. He couldn't stop the ideas swimming in his head from exiting through his fingers. Ralph was a passionate guy and he poured out that passion in many ways, but once he began painting that was his primary form of release. I inherited his passion for politics and a life of the mind, but my strengths lie in being able to articulate the ideas that swim in *my* head verbally, in writing, and in the creation of the built environment. Like him, I have a nearly obsessive need to use my hands, and the creativity he imbued in me has led me to try to balance a teaching career with work in wood and the preservation of our ecosystem.

I have studied some of my father's canvases my entire life. Every time I look at them I see something new. His most accomplished works reveal the perversions and promises of the United States: the history of prejudice, oppression, and wage slavery, and the power of opposition, hope, and the struggle for a more egalitarian society. He painted the beauty, poetry, and social cohesion that define a healthy existence. He communicated these concepts by employing the emotional resonance of persuasive visual metaphor. He painted optimism. My dialog with my father's paintings moves me and propels me to engage in and advance the discourse of the pressing environmental and social issues affecting the human condition today.

Though I knew my father in a way many never could, I am still amazed that the son of an immigrant iceman, who worked in New York City with a horse and wagon, and a turn-of-the-century seamstress, who became radicalized on the factory floor, emerged from a Little Italy tenement to become an artist many consider to be America's most articulate self-taught painter. His canvases capture the anguish of his lifetime, and they bolster us with his visionary dream for our future.

Ralph Fasanella painting *Marc's World* in his Ardsley, New York, studio

Pie in the Sky

My father's parents, Giuseppe and Ginevra Fasanella, were products of the nineteenth century. Reared in Lavello, Italy, a city dating back to the Middle Ages, they immigrated to New York City in about 1911, after the birth of their first son. Giuseppe found work in Little Italy and eventually acquired routes delivering ice to Brooklyn apartments. Ginevra took work in the needle trades, including a stretch as a seamstress in the infamous Triangle Shirtwaist factory (after the fire). They prospered enough to relocate to the South Bronx by 1925, but the modernizations of the industrial age proved too much for my grandfather, and he returned to Italy in 1954.

My father was really raised in two cities. The lower Manhattan of his early youth was a teeming immigrant enclave, dense with a chaotic mix of specialty-food vendors, light industrial workshops, overcrowded apartments, and organized crime. The move north of Manhattan to the South Bronx introduced the young Ralph to open spaces, sandlot baseball, and the effects of upward mobility and suburban expansion. The combination of these two environments left an indelible impression on him, and he was able to understand New York's strengths and weaknesses.

Ralph grew up in difficult times. He was born in 1914 at the start of World War I. As the tides turned against European empires, political and class divisions deepened in the United States, and the Great Depression ensued in 1929, just as he was forming his intellectual identity. He had recently gotten out of a Catholic protectory (reform school), where hunger, cold, dampness, high walls, and basement spaces were offset by the resplendent vestments worn by the clergy and the mysterious abstraction and color of stained-glass windows. These symbols brightened the physical and economic darkness of an otherwise bleak incarceration. Once released, he was greeted with unemployment and poor living conditions, punctuated only by the kind friends and family who warmed his existence. To him, the colors of the stained-glass windows and the sunlight that lit up the courtyards and streets of his youth were outside forces. Ralph's earliest paintings reflect these dark times, portraying even outdoor scenes as interior spaces. The atmosphere and buildings are crudely depicted in combinations of red and muddy gray, brown, and black.

In his 1947 painting *Wall Street* (p. 34), a darkened alley hemmed in by uniform black buildings with coffin-like rooftops covers three-fourths of the canvas; an ominous church at the end of the narrow street emits a dim light. At the top of the canvas an urban waterway glows with an eerie orange light. My father saw in his mind's eye, and depicts on this canvas, the weight of the Great Depression. The soul-crushing emptiness of an urban setting stripped of its economic activity left an indelible mark on his psyche.

In 1937, Ralph volunteered as a driver for the Abraham Lincoln Brigade and joined other progressives overseas to fight in the Spanish Civil War in support of the popular front and against fascism. He returned to the United States the following year and found work as a machinist's apprentice. In 1939 the Republican army surrendered, and a fascist dictatorship took over rule of Spain.

In the aftermath of the Spanish Civil War, World War II had begun, and the community of Ralph's peers was in a deep state of collective depression. Not one for mathematical precision and repetitive tasks—and propelled by unflagging curiosity, a gift for engaging and sustaining

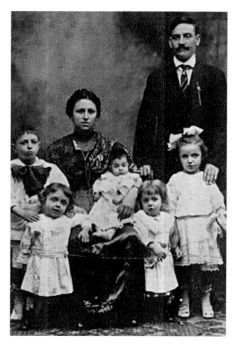

Ginevra and Giuseppe Fasanella with their eldest five children (Ralph second from right), c. 1915

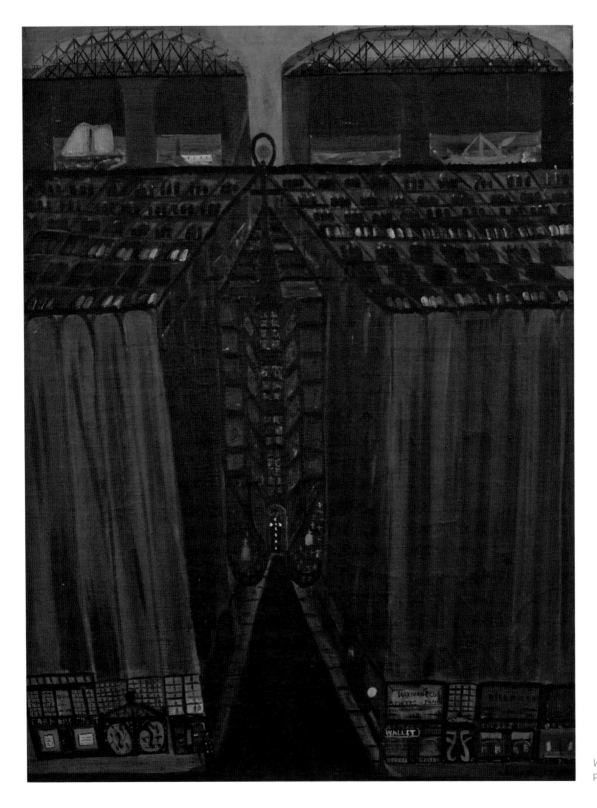

Wall Street, 1947. Oil on canvas, 29 x 22 in.
Private collection. Courtesy Andrew Edlin Gallery

people in conversation, and progressive ideals forged in discussions with his garment-worker mother and sisters at the family table—my father gravitated toward union organizing. When the war ended, fascism and its attendant prejudices and anti-democratic ideals, though defeated in Germany and Italy, remained in power in Spain and had taken root in many communities throughout the United States. A powerful sentiment emerged in the United States against progressive ideology. Ralph found his work as a union organizer extremely fulfilling, enjoying his collaboration with union leaders as well as workers on the factory floor, but he began to feel harassed as the nascent McCarthy era gained traction.

Such is the context that led my father to paint *Pie in the Sky* (p. 36) in 1947. The blockish composition is flanked by crudely formed, tall apartment buildings. On the left, a liquor advertisement shouts the false promise of a clear head and a healthy rural existence; on the right, the clean apartments of workers appear oversized, connected by a fire escape, and are exposed like buildings with missing walls in wartime photographs.

Ralph Fasanella with *Other Side of the Tracks*. Courtesy American Folk Art Museum. Photo by Albert A. Freeman

In the center of the painting is a cleft, lit by the colorful apartment windows that inhabit the walls of the city block and barricaded by an ominous church—red, the color of passion, love, seduction, violence, danger, anger. Children play in the street in front of the church. Mothers, fathers, and grandparents watch over the children and socialize.

Pie in the Sky clearly connects the spiritual, political, and economic oppression that had been so tantamount to Ralph's existence. His time in the protectory had left him with the image of individual souls rising out of an intensely dark environment, enclosed by but somehow surpassing the suffocating atmosphere. Each small figure in the work is thickly painted, relief figures physically rising out of an otherwise largely flat surface, save for the coarse, vibrating texture of the church and the sky of heaven. Bright, sun-washed clothes adorn the tops of the buildings, their kite-like playfulness in poignant contrast to the heavy roofscape. The gates to heaven, as promised to my father by the clergy of his youth, crown the apartments. To the left of the gates, a multiroom home floats atop clouds, as dreamed of by Ralph's brothers during their two-room tenement upbringing. To the right of the gates, a flower garden, child's wagon, sailboat, archery set, and slide hover above the children who will likely never have the opportunity to enjoy them. The bittersweet melancholy evident in postwar Italian neorealist cinema is reflected in this painting, with the darkness of poverty punctuated by dreamlike moments of hope.

In the large sister painting *Other Side of the Tracks* (p. 38), painted the same year, the theme of escape to a more comfortable existence is reiterated. In the following year, 1948, Ralph painted *Sam's Dream* (p. 39), a depiction of his brother's aspiration to escape the oppressive atmosphere of the city, like that of so many immigrant families who made the exodus from Little Italy. But in his homage to his brother's yearnings, my father does not fully embrace the notion of suburbia. The scale of the buildings is disturbing, the ground erratically undulates, and the trees are stark and bare. His rendition of Sam's idealized world bears more resemblance to a cemetery in turmoil than the tranquil setting his brother surely had in mind. Most disturbing to my father, and expressed in this canvas, is that the scene is devoid of people. For my father, people animated a landscape. Without them, Ralph was in a purgatory.

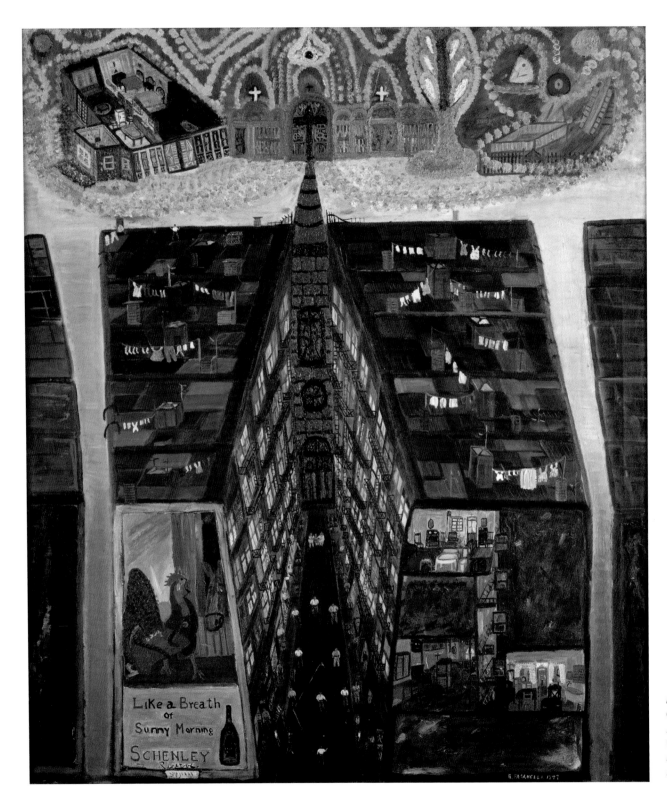

Pie in the Sky, 1947.
Oil on canvas, 45 x 38 in.
American Folk Art Museum,
New York. Gift of Eva Fasanella
and her children, Gina Mostrando
and Marc Fasanella, 2005.5.4

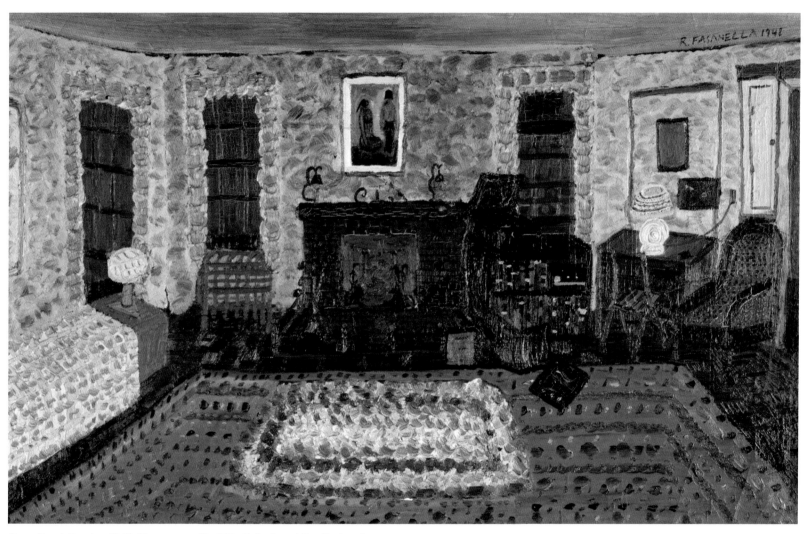

Grove Street: Fireplace, 1948. Oil on canvas, 16 x 26 in. Collection of Gina Mostrando

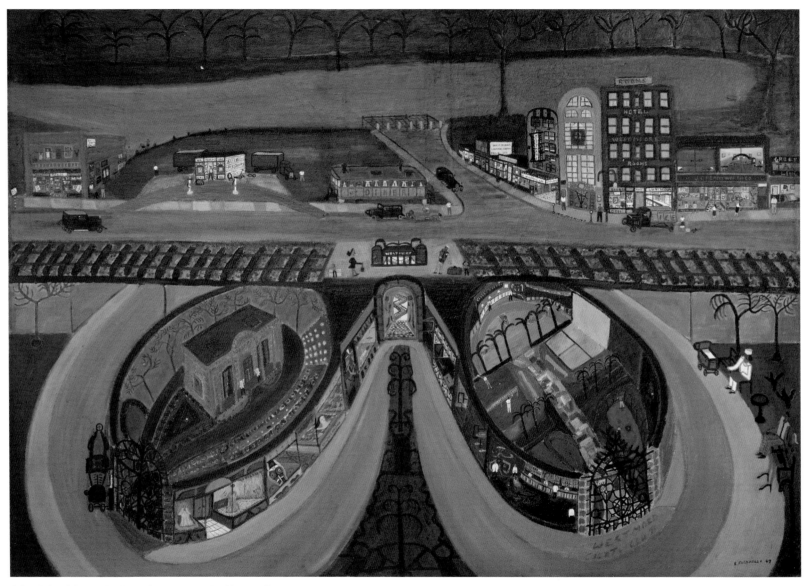

Other Side of the Tracks, 1947. Oil on canvas, 42 x 60 in. Hudson River Museum, Yonkers, New York

Sam's Dream, 1948.
Oil on canvas, 59½ x 50 in.
Courtesy Andrew Edlin Gallery

Altar, 1947. Oil on canvas, 30 x 20 in.
Collection of Gina Mostrando

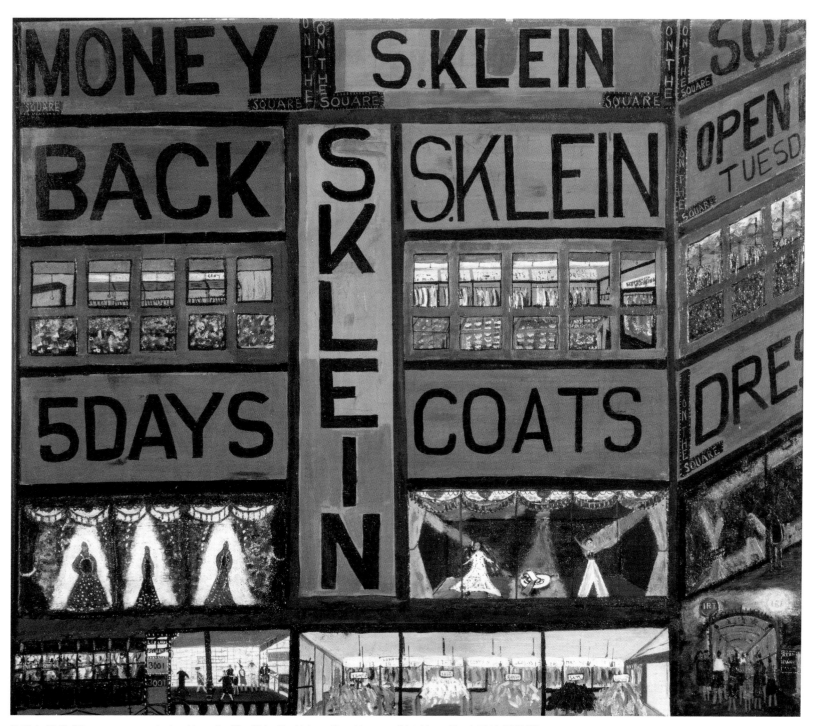

S. Klein, 1949. Oil on canvas mounted on Masonite, 23 x 27 in. The Metropolitan Museum of Art. Mayer Fund, 2001, 2001.518

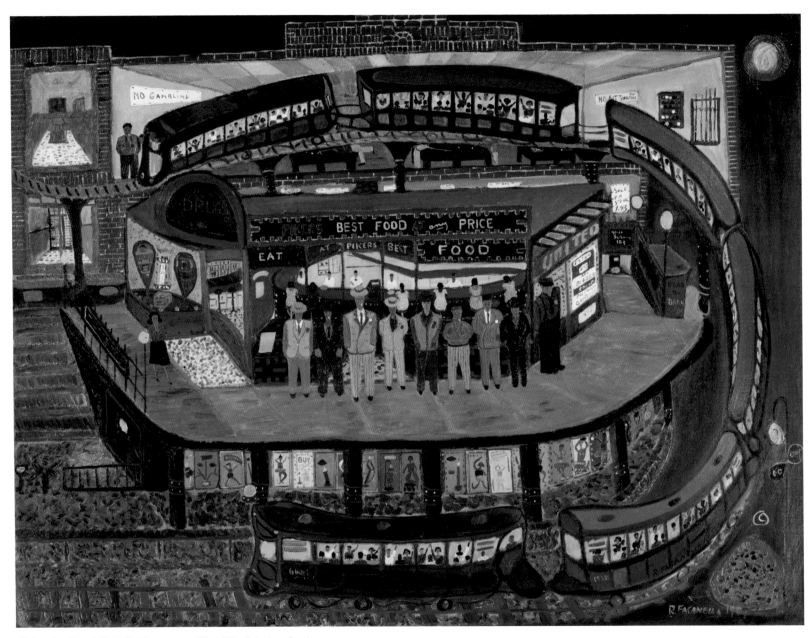

Christopher Street #3, 1947. Oil on canvas, 30 x 40 in. Private collection

Tony Pastor's Bar, 1947. Oil on canvas, 34½ x 52 in. Fenimore Art Museum, Cooperstown, New York. Gift of Jane Ferrara in memory of Ronald A. Ferrara, N0013.2005(01)

Grand Union

My father had an incredibly active mind, incessantly absorbing new information and forming a theoretical and visual collage of ideas from the events of his daily life. The inequities of the first half of the twentieth century made no sense to him. He could "see" how people should live—it was so "goddamn clear." But as the decade of the forties closed, his mood lightened. He began to reflect on his past in positive ways. He appreciated the beauty of the important relationships he had formed, including his strong bond with his sister Tess, with whom he shared an apartment for a time.

Ralph's experiments with oil on canvas became more successful, and he began to develop a remarkable facility for capturing interior and exterior scenes. In his painting *Honeymoon, Yellow Cabin*, he carefully depicted the tranquility of my parents' waterside vacation after their wedding. The painting *Sunday Afternoon* (1953; p. 49) recalls the crowded streets of his tenement childhood as well as the energetic creativity of the kids who transformed the street into a stickball field and made uniforms for their teams. The conviviality of the parents cheering the children on and enjoying each other's company along the sidewalk also brightens the scene. In *Sandlot Game #2* (1957; p. 48) he revisited the carved, improvised field built by his neighbors in the Bronx.

Just past the northwestern edge of the Bronx, a shoreline string of Westchester County towns dots the linear edge of the Hudson River. One of these is Dobbs Ferry, a hilly, wooded community of modest homes, old stone walls, and an Italian American core community that formed its architectural and storefront culture in the post–World War II era. My father must have visited the town in the 1950s, and the image of the market he placed at the center of the canvas in *Grand Union* (1955; pp. 46–47) clearly grasped his imagination. No doubt the name of the grocery store chain resonated with him: he had worked in other river towns, such as Hastings-on-Hudson and Irvington, as a union organizer.

In *Grand Union* Ralph painted his ideal of a suburban utopia. The winter scene—rare for Ralph—shows a composite of vignettes drawn from his experiences working in lower Westchester County over the previous two decades. In the foreground, the neatly cleared parking lot represents the encroaching car-centric development that was increasing dramatically with postwar production, concurrent with chain stores replacing independent greengrocers. The interior of the store is a vibrant, futuristic, abstract space filled with fluorescent light and color that is impersonal but clean, well ordered, and efficient. The scale of the two women just in front of the store, with its wall of glass windows removed, is almost comical when compared with the diminutive cars and people that appear in the foreground. To the right of the women, a pickup truck and a delivery vehicle of contemporary vintage are at odds with the cars from a much earlier time. The 1920s-model vehicle parked in a snowbank at the extreme right of the canvas sits in front of a row of small shops with apartments above, a vestige of another time. At the base of the hill, a tractor trailer departs into a tunnel after dropping off goods. Above it and to the right, a boy prepares to sled down the hill in front of an old stone church, similar in design to a Roman Catholic church that sits near the Grand Union in Dobbs Ferry today. Another tunnel appears behind the boy, and above it and to the left is a hilly scene of quiet suburban life. Cozy houses are set in a wooded landscape, in the middle of which a country road and train tracks converge at a pond where a group of children skates.

The half dozen houses, ranging in size and style from wooden cottages to a multifamily home, a Cape Cod, and a mock Tudor, accurately depict the early housing stock of Dobbs Ferry and the surrounding communities. This canvas portrays the postwar genesis of the dense network of residential development so common today in the Northeast.

At the left of the painting, a row of multistory brick buildings forms the main street of a remote Hudson Line train stop—a stop and street so small that they do not warrant a station. Instead, the cast iron colonnade used during the nineteenth century to provide travelers some minimal respite from the elements represents an earlier time.

Farm fields lie behind the main street, indicating the train as the primary source of trade and commerce to an isolated community north of the city. Fronting the street, my uncle Nick's gas station features two pumps. (While Ralph's brother Nick did own gas stations, none of them was located in Dobbs Ferry.) The station is remarkably similar to one in the town where I grew up, Ardsley—the next town east from Dobbs Ferry.

Honeymoon, Yellow Cabin, 1950. Oil on canvas, 24 x 30 in. Collection of Gina Mostrando

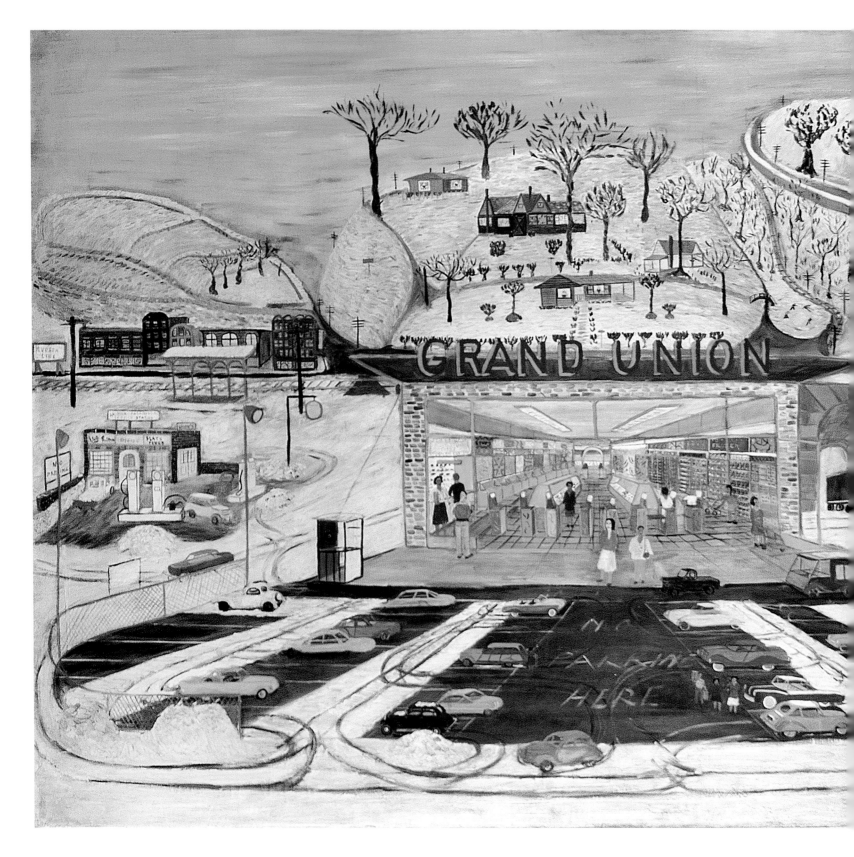

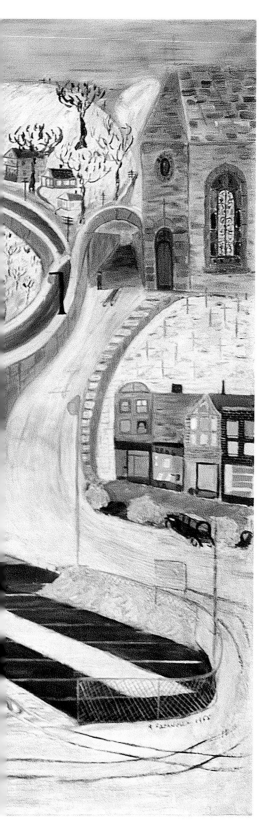

It's clear to me that Ralph was contemplating modernity in *Grand Union*; the painting offers a prescient message for 1955. Past and future are simultaneously shown side by side: the large store at front and center is framed above by rural life and below by a large parking lot, with modern lighting and a chain link fence; to the left and right, the small main streets and historic church are balanced by the gas station; and the tunnels where the tractor trailer enters and the boy exits are heading into opposite perspectives. Then there's the oversized phone booth positioned at the upper left corner of the parking lot: it is a modernist red-and-white box, but it holds within a black, double-bell wall phone from a much earlier time.

My father talked about his brothers dreaming of a new life in suburbia, a place where their children could spend time outdoors and have space to breathe. But Ralph always found suburbia antisocial and bourgeois, lacking the earthiness and dynamism he found in the city's neighborhood bars, luncheonettes, cafés, and shops, and in neighbors convening on stoops. He and my mother eventually did move the family out of the city in 1964, the year I was born, but my father missed the cigarette smoke, the sounds of an industrious life, the smells of numerous kitchens, and the fabric of urban life.

Grand Union, 1955. Oil on canvas, 50 x 72 in.
Collection of the Hudson River Museum, Yonkers, New York.
Gift of the Estate of Ralph Fasanella, 2005.01

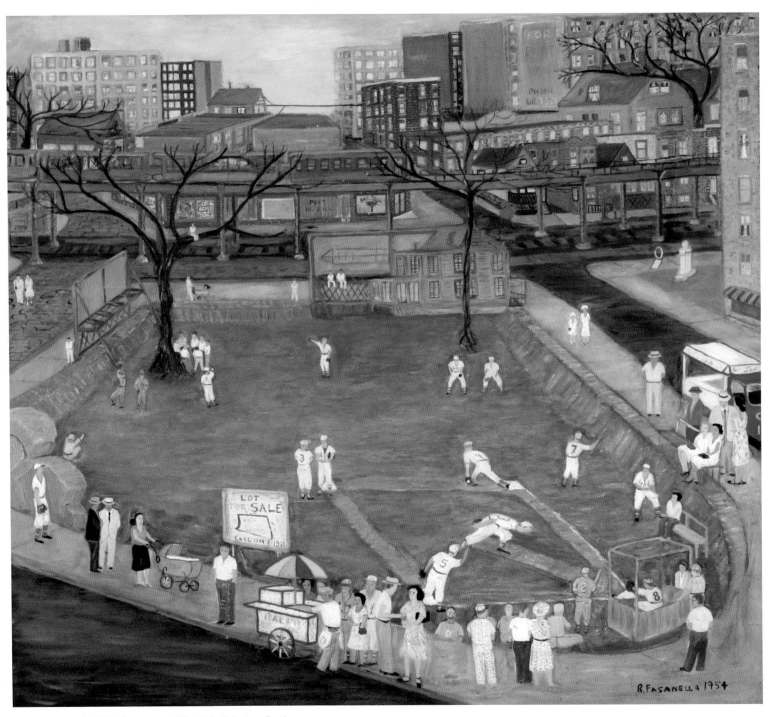

Sandlot Game #2, 1957. Oil on canvas, 36 x 40 in. Private collection

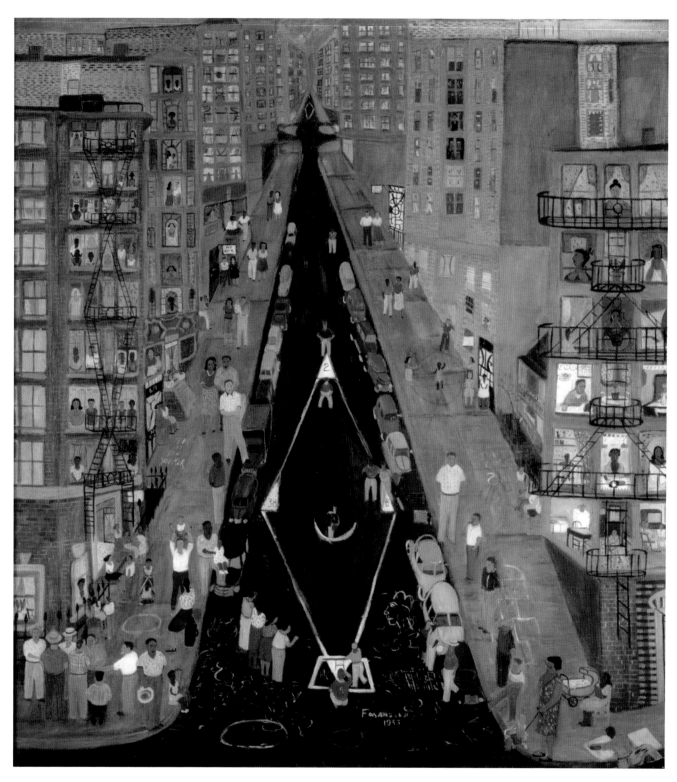

Sunday Afternoon, 1953.
Oil on canvas, 40 x 36 in.
Private collection

Following spread:
New York City, 1957.
Oil on canvas, 50 x 110 in.
Private collection

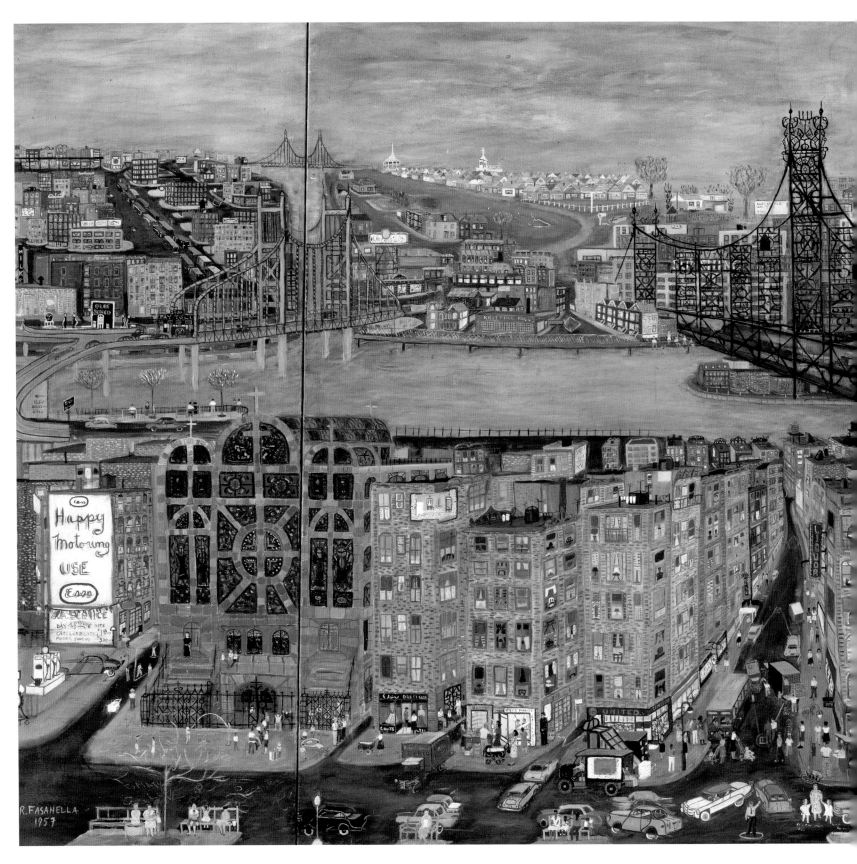

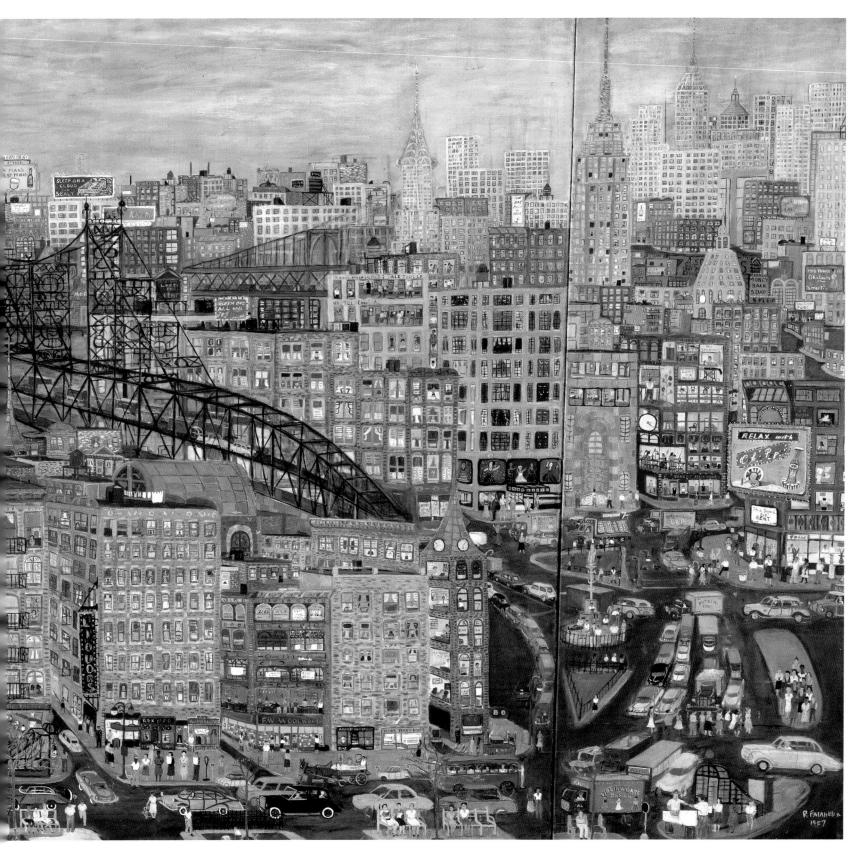

The Iceman

I grew up with the painting *Iceman Crucified #4* as a powerful presence in my life. I have come to love it as a family member, and I have always seen it as a positive image—a depiction of a happy, working-class life devoid of hardship and suffering, and of a community transcendent from the suffering of its forebears.

My father depicted his father, Giuseppe, or Joe, in several paintings as a man crucified, long suffering and little understood. As a young boy, Ralph rode on his father's horse and wagon while Joe delivered ice to the many tenement dwellers for whom a refrigerator was a luxury they could not afford. He often told me about the long days they would put in, he and Joe walking up three or more flights of stairs with a large block of ice resting upon a shoulder—a memory that informs the foreground of the 1958 painting *Iceman Crucified #4*. Though my grandfather appears crucified at the center of the painting, I do not find the image sorrowful or melancholy. This crucifixion represents the visible relief from the suffering that Joe endured and that is memorialized in the message written over his head: "Lest we forget."

The placid, sleeping face of this man I never knew is an icon that expresses the tribulations of working people everywhere. Joe's relaxed posture belies the circumstances of the hard work he undertook to support his family and the circumstances of his symbolic crucifixion. Though his right hand is nailed to the cross by an ice pick and his left hand supports a wooden bucket loaded with a heavy block of ice, Joe is finally, perhaps eternally, at rest. A cigarette tucked behind his ear beneath a snug wool workman's cap is an indicator of his place in society.

The cross of Joe's crucifixion stands before an icebox. On top of it, to the right, sits a triangular napkin presenting Joe's diminutive alarm clock and his morning espresso and cigarette, with his ice pick ready at hand. His pack of Camel cigarettes is neatly tucked in his shirt pocket and his feet are bare on the linoleum floor next to a welcome mat. Inside the oaken icebox, the essentials of the Italian American immigrant table appear like offerings to Joe and vestiges of the world he is leaving behind. Among the fruit, cheese, cured meat, vegetables, and wine is a newspaper that contains a headline for Babe Ruth, whose career ended in 1935 while Joe was working in New York, and Jackie Robinson, whose career began in 1947.

My definition of paradise, drawn from various sources, is a place in which existence is positive, harmonious, and timeless, and a counter-image to the miseries of human civilization; a place of contentment, but not necessarily of luxury and idleness. The background of *Iceman Crucified #4* is a depiction of such a utopia where the positive aspects of human communities make them joyous and uplifting. Joe's tenement neighborhood stoop lies beneath his feet, but it is populated by residents who are wearing clothing he would likely have never seen during his time in New York. Tony Pastor's bar, Grove Drugs, and the Empress Bar are all places that meld the nineteenth-century world of Joe's lower Manhattan with the early twentieth-century neighborhoods of my father's youth. A young man in jeans and a T-shirt feeds Joe's horse. The brightly colored wooden wagon, with an old-style typeface and wood-and-iron wheels, is clearly out of sync with the refrigerator being lowered from a modern truck tailgate in the lower left-hand corner of the canvas. The building above the truck houses a new pharmacy and is racially integrated, something else Joe would not likely have seen in his time in New York. On the roof of the building a man stands in the clothing of a worker, having just released his pigeons, a hobby my father pursued in his youth. The man looks out over a plank that supports a block and tackle holding a giant pair of ice tongs, which support the icebox behind Joe. To the right sits a neighborhood on the outskirts of the city. It could be the Brooklyn, Bronx, Queens, or Yonkers of midcentury New York.

The earlier *Iceman Crucified #3 (Passing of an Iceman)* (1956; p. 54) expresses many of the same themes in a more simplified and direct way. My father appears three times in the picture: in the lower right he watches the raising of his father's icebox-cross; beneath the icebox he pulls a rope that secures a pair of ice tongs and roots the crucifix to the ground; and in an upper left apartment he lowers the icebox by means of another set of tongs, making space for the refrigerator that is to be hoisted into the apartment, replacing Joe's trade. The medieval city of Lavello, the place of Joe's birth and retirement, floats above the apartment buildings.

The fresh air, sunlight, and modernity of the neighborhoods that compose the settings of my father's crucifixion paintings affirm Joe's success as an immigrant. His children ascended from their tenement youth to an existence of relative leisure and comfort—one the early twentieth-century immigrant Giuseppe Fasanella must have been striving for. Joe the iceman can rest and leave the work to others. What he had set out to do, he had largely achieved.

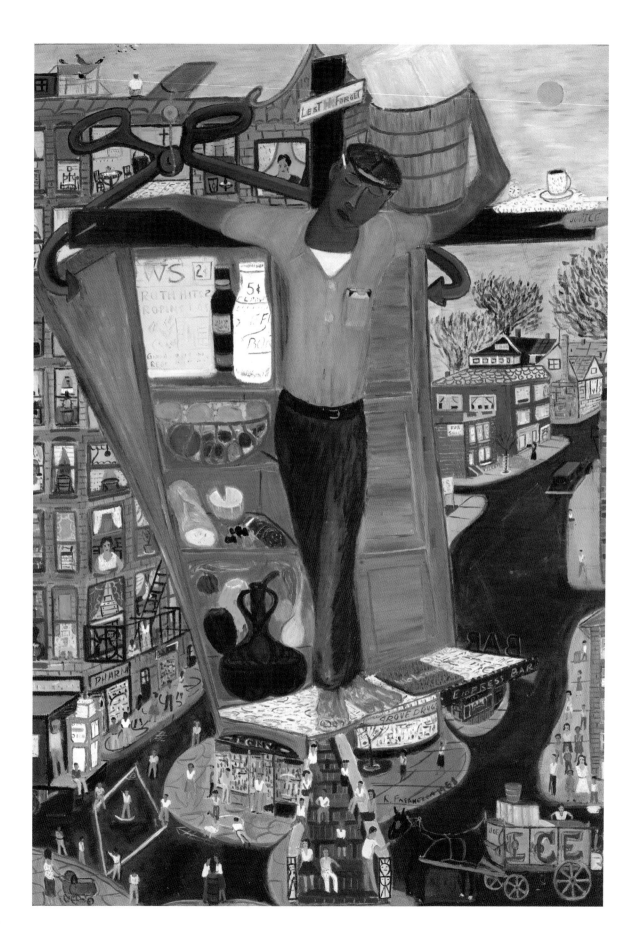

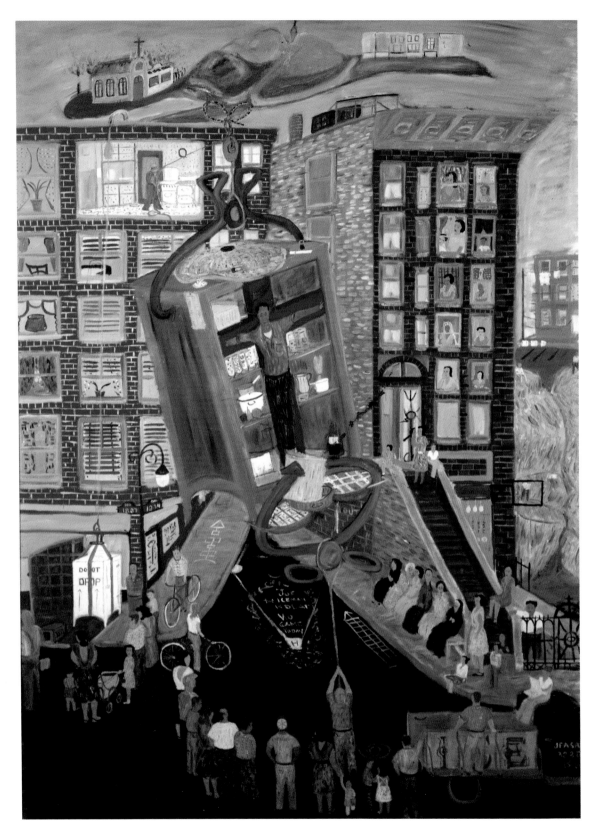

Previous page: Iceman Crucified #4, 1958.
Oil on canvas, 36 x 25 in. Smithsonian
American Art Museum. Gift of the Estate of
Ralph Fasanella, 2013.69

Iceman Crucified #3 (Passing of an Iceman), 1956.
Oil on canvas, 36 x 25 in. American Folk
Art Museum, New York. Gift of Patricia L. and
Maurice C. Thompson, Jr., 1991.11.1

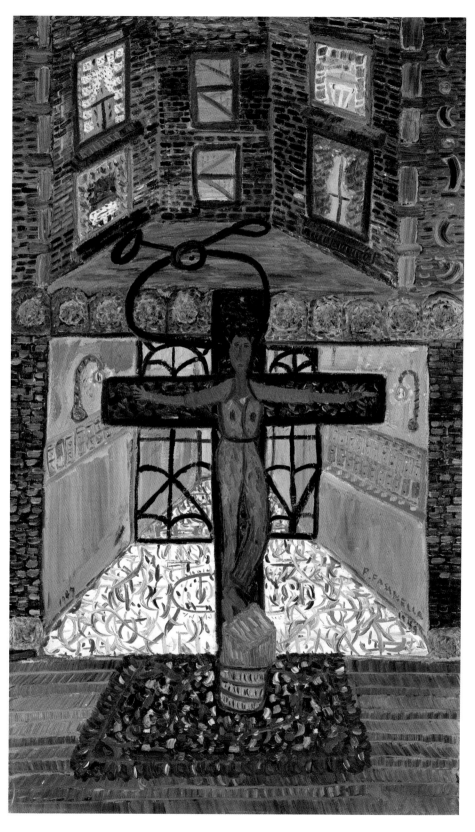

Iceman Crucified #2, 1949. Private collection

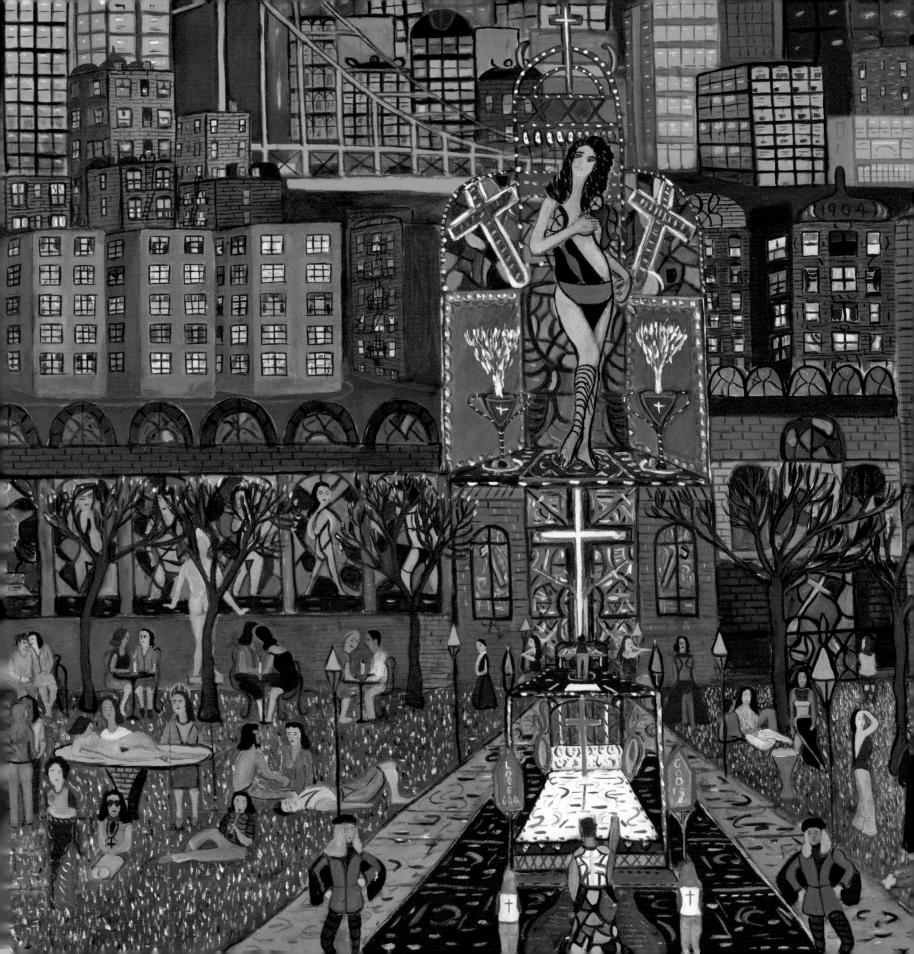

Love Goddess

By the time he reached fifty, and after two decades of practice, Ralph had begun to express his thoughts articulately with a paintbrush, and they exploded onto canvas. Ideological passion drove him to paint—not a passion for the art of painting, but a passion for the lives of the people. He painted energetically into the wee hours of the morning, fueled by cigarettes, coffee, and the power of his ideas. His technique constantly evolved; he had no one right way, and his work was not dogmatic. He taught himself to paint by studying other artists and visiting museums. Brueghel, Goya, the impressionists, Van Gogh, Picasso, Rivera, the Ashcan school—he read about them voraciously and saw any exhibits of their works that he could. Because of my father's innate insight into artistic expression, my sexual identity was informed by the paintings of Gustav Klimt. I remember my father coming home from a trip into the city and giving me a folio of loose prints he purchased at a museum bookstore. I was just reaching puberty. I pored over the prints, sorting them and selecting those I liked best, and I studied them before going to sleep. I felt I was having an artistic communion, not with Klimt per se, for I was far too young to understand who he was and his place in art history, but I was mesmerized by the images, seduced by their trancelike quality, their sensuousness, and the balanced opacity and translucence they displayed. These were erotic experiences both carnal and intellectual. The languid, beckoning gaze of the women, the crouched, lean, muscular physicality of the men, and the embraces they shared awoke my sensuality.

Klimt's complicated compositions include nude or seminude figures ranging in age from infancy to decrepitude. They introduced an idea of human sexuality based not in exploitation but in shared visceral experience. The eyes and postures of his women beckoned me into a mental relationship that was complicated and deep, if furtive, and separated from me by nearly a century. I wanted to know them, touch them, hold them, and love them. The time I spent with these works taught me the depth of art, the aesthetic, emotional, and even erotic impact an enlightened hand can have on countless viewers.

As an adult I chose to live with my father's painting *Love Goddess*. Though lacking Klimt's technical mastery, my father's painting has broadened my view of sexuality over the years. When I remodeled a former family home, I designed a bedroom around the painting and positioned it at the foot of my bed. Painted in the year of my birth, 1964, the central figure—a sexual-revolution version of Botticelli's Venus—presides over a churchyard. She has the languid pose and soulful eyes I had come to know through Klimt. An alluring presence, she sets the crosses that flank her off kilter and dominates the scene with suggestively clothed sexuality. A female messiah on a platform topped with a small swordlike cross and the Times Square triple-X marquee of her intent, she is in erotic repose, atop an altar, dwarfing the churchyard and bed beneath her. The love goddess is attended by a free-love ministry that includes a few monks, a priest, two young pages bearing her banner, and a female Swiss Guard in mod uniforms. Her extended flock includes people sharing time with each other, couples—both hetero- and homosexual—and groups of various genders and ages, in tentative intimacy. They relax and animate a lively urban space.

To the right, a church looms out from the canvas. Its rosette and other stained-glass windows lack depth and have become transformed into a meaningless series of modernist, impressionist, and Africanized motifs. An imposing edifice of warm purple and cool blue-green, the church inhabits more than half the canvas, balanced on the left by a nude figure lying on a dais. A confident young woman in the context of both Titian's so-called *Pardo Venus* and Édouard Manet's *Luncheon on the Grass*, and reclining in an Amedeo Modigliani pose, she is comfortable in her skin, unthreatened by her observers and the congregation around her. Delicate and alluring, she renders the strippers in the windows behind her formless and offsets the blockish church with her grace.

When I discussed *Love Goddess* with my daughter, Mia, she pointed out how the painting reveals a utopia, cloistered by the church and its courtyard from the indifferent city that looms beyond. People sit, lounge, and recline in comfort—with themselves, with each other, and seemingly with the world at large. The scene, filled with ease and warmth, stands apart from the tenements, housing projects, and modernist backdrop of skyscrapers against a foreboding red sky. Mia contended that *Love Goddess* illustrates that religion blinds people to the opportunity to

Love Goddess (detail; pp. 60–61), 1964

create a heavenly existence here on earth, as the focus of Catholicism is often in the hereafter. Her brother, Michael, pointed to the valuable role many faiths play in bettering the world and cited the organized ministry of the civil rights movement as one example. Of course they are both right: religion has performed in these ways throughout history—and my father's painting keenly offers the basis for both interpretations.

Love Goddess is a hopeful painting, a utopian notion of human sexuality built upon but unencumbered by the Catholic notion of sin. Having been committed three separate times in his youth to a Catholic protectory run by monks, and knowing the oppressive guilt of original sin, he created this painting to rise above it. The counterculture of 1964 offered hope against a setting of intolerance, and *Love Goddess* offers a glimpse of the complexity of that era.

Like Klimt, my father painted in a flattened, overlapping composition of varying scale, but in the color and texture of his time. The erotic works of Klimt taught me intimacy, the tenderness of the human form, and the meaning of passionate embrace. *Love Goddess* expanded my sexual consciousness outward to political thought, taught me aspects of feminism, opened my mind to the continuum of human sexuality, and provided me with insight into the meaning of community and worship.

Lineup at the Protectory #2, 1961. Oil on canvas, 30 x 47 in.
Private collection. Courtesy Andrew Edlin Gallery

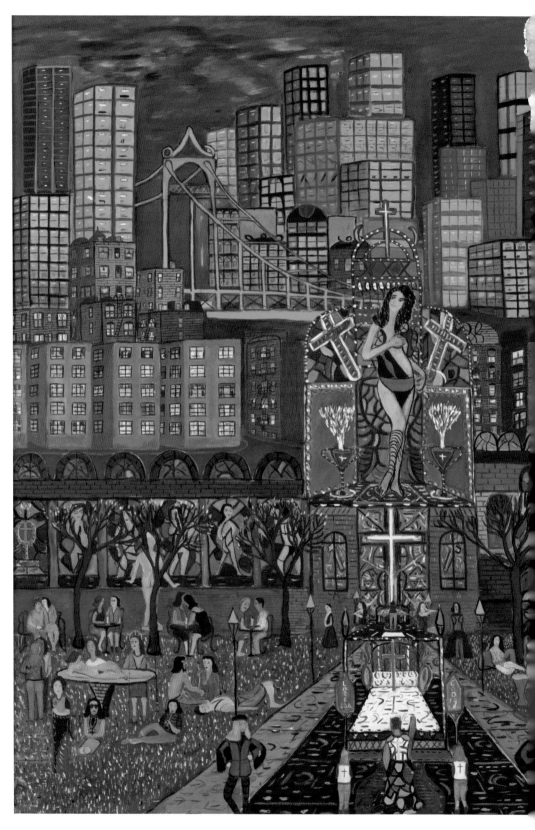

Love Goddess, 1964. Oil on canvas, 44 x 80 in.
Courtesy Andrew Edlin Gallery

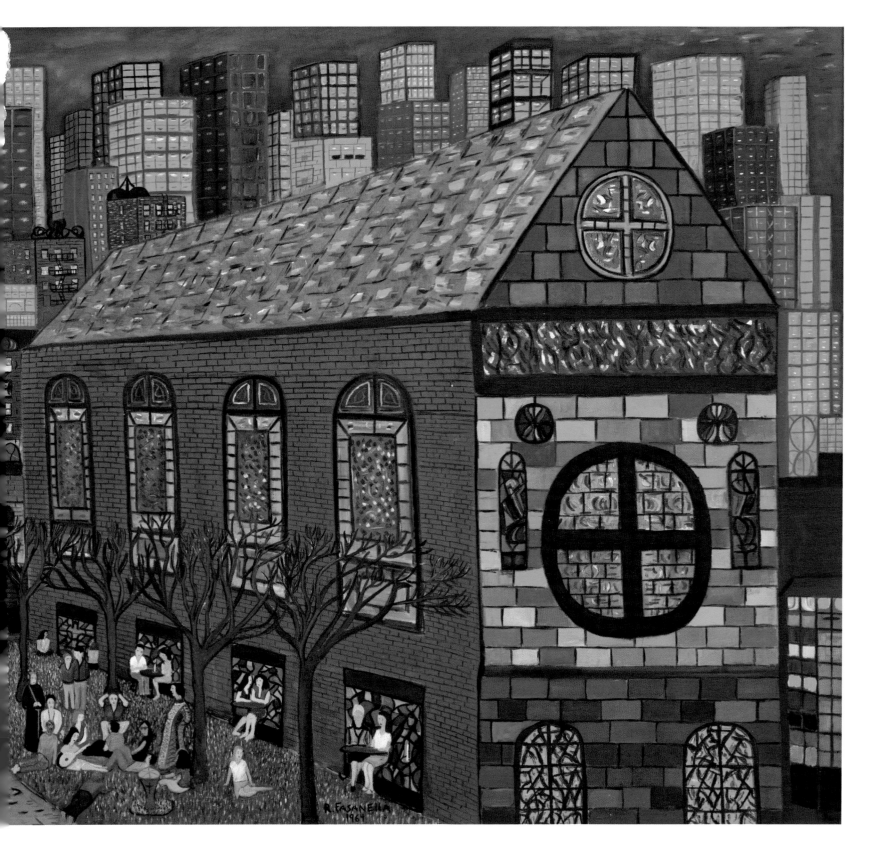

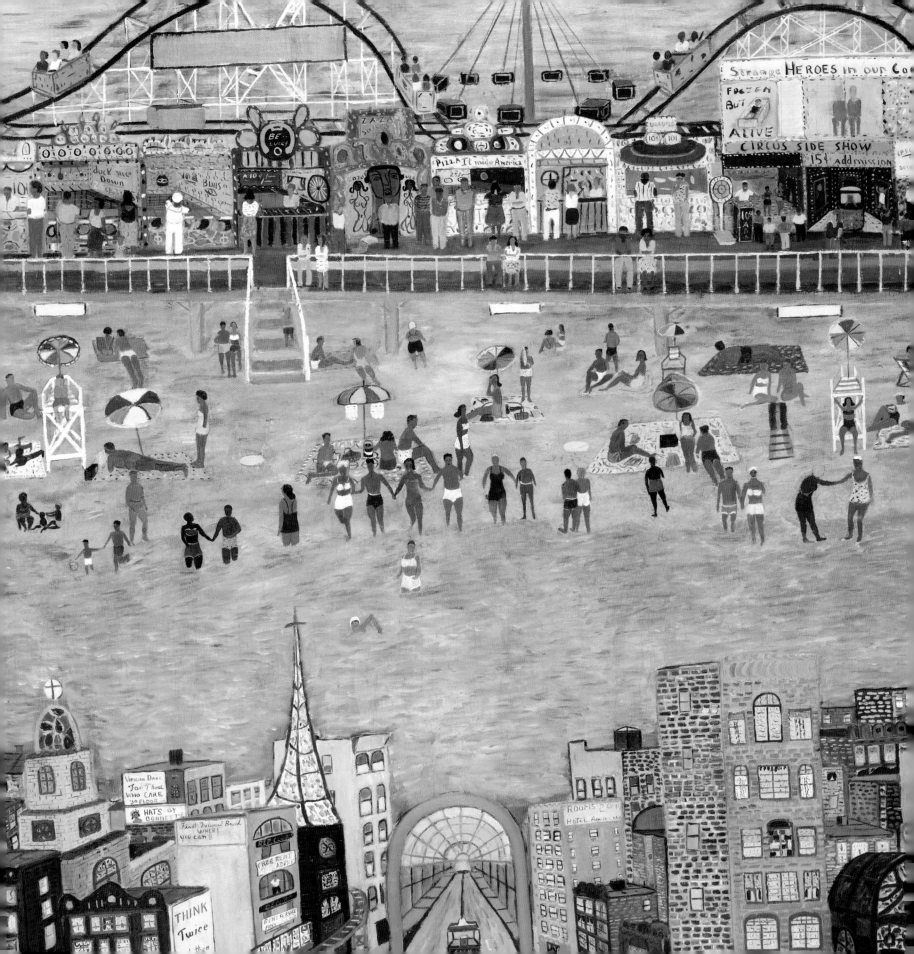

Coney Island

None of Ralph's utopian visions reaches the level of a fantasyland in the way *Coney Island* does. The lowest third of the wide canvas is split by an entrance tunnel to the beach paradise. No matter that no such tunnel exists; it is a useful metaphor for escape from the narrow alleyways formed by the buildings and heat of the streets depicted on either side. In the lower left-hand portion, three churches, including a fantastic blue cathedral in the foreground, grace a prewar neighborhood similar to those he depicted more crudely in some of his earliest work. The bars, grocery store, and For Rent signs that mark the declining economy of the Great Depression are scattered among the multistory apartment buildings. In one building to the left of the tunnel, a man stands at a window framed above and below by signs proclaiming Free Rent Advice and Rent Service Free; he may only be observing the exodus of the city's denizens beneath him, or perhaps he is contemplating suicide. (My father once told me that he witnessed one of the many entrepreneurs broken financially and emotionally by the Great Depression fall to his death just in front of him.)

To the right of the tunnel entrance sits an evolving neighborhood of both pre- and post-Depression-era buildings, including a small, ornate church that is dwarfed by its surroundings, in contrast to the dominating blue cathedral. From my father's experience living in the Catholic protectory (he was placed there as punishment for truancy and theft), he no doubt felt more comfortable with a diocese having a subordinate influence in a neighborhood—represented on this side of the tunnel—as opposed to a superior one. In this neighborhood, the bars and For Rent signs of his Depression-era youth are replaced by street-level storefronts, including an art supply store, a frame shop, and a market, as well as a banner advertising the candidacy of Vito Marcantonio for mayor. In 1949, Ralph ran for city councilman on the American Labor Party ticket with Marcantonio (for whom I was named). This is a city neighborhood my father would have felt at home in: clean, well ordered, and populated by families—not the barflies and zoot-suiters of the neighborhood to the left.

But from both sides of the canvas a stream of vehicles heads toward the Coney Island tollbooth. They are greeted by the bright billboard message, "Good morning. Have fun. Enjoy the beach." Above the toll and tunnel an expanse of saltwater separates the dense urban blocks below from the more expansive seaside landscape above. The well-groomed, monochromatic, diminutive people in the city streets at the bottom of the canvas are replaced and dwarfed by multihued beachgoers reveling with each other in the sun-soaked sand and sea. Though there are two concession stands, there are no advertisements or prices posted on the beach. It is a cost-free place of contentment and restorative idle play. The beachgoers read, relax, and bathe in a community of goodwill. People hold hands and lie close to each other in friendship and intimacy, undisturbed by both the city they left behind and the carnival activity colorfully taking place beyond the beach. The creatively painted wooden booths along the boardwalk provide beachgoers with a panoply of entertainment, ranging from the famed Ferris wheel and wooden Cyclone roller coaster to an array of games of chance, the allure of the Zaza sisters, and a patriotic sideshow featuring "One Bomb Bob: Capt. Robert Smith destroyed 1 Korean city with 1 bomb."

In *Coney Island*, Ralph effectively concocted a convincing set of improbable perspective views uniting a canvas of highly disparate scales and planes into a cohesive story. The lower cityscape makes use of one-point perspective, with its vanishing point set in the middle, while above, a marvelous use of flattened, impressionist, atmospheric perspective defines the sea and beach. The interiors of the boardwalk booths display various perspectives but are united by their scale and depth. Though Ralph completed the canvas in 1965, when he was accomplished in his ability to visually communicate depth and perspective, the painting presents some of his earlier, more primitive techniques.

My father's goal was never the accurate depiction of reality. He wanted to convey simultaneous scenes, layer meaning, and show motion and the advancement of time. Like his contemporary abstract painters, he sought inspiration from all the art that came before him and strove to depict new realities with his own vocabulary of form: his people, their communities, and the promise the union movement held for a more egalitarian existence.

Coney Island (detail; pp. 64–65), 1965

Coney Island, 1965. Oil on canvas, 59 x 96 in.
American Folk Art Museum, New York.
Gift of Maurice and Margo Cohen,
Birmingham, Michigan, 2002.1.1

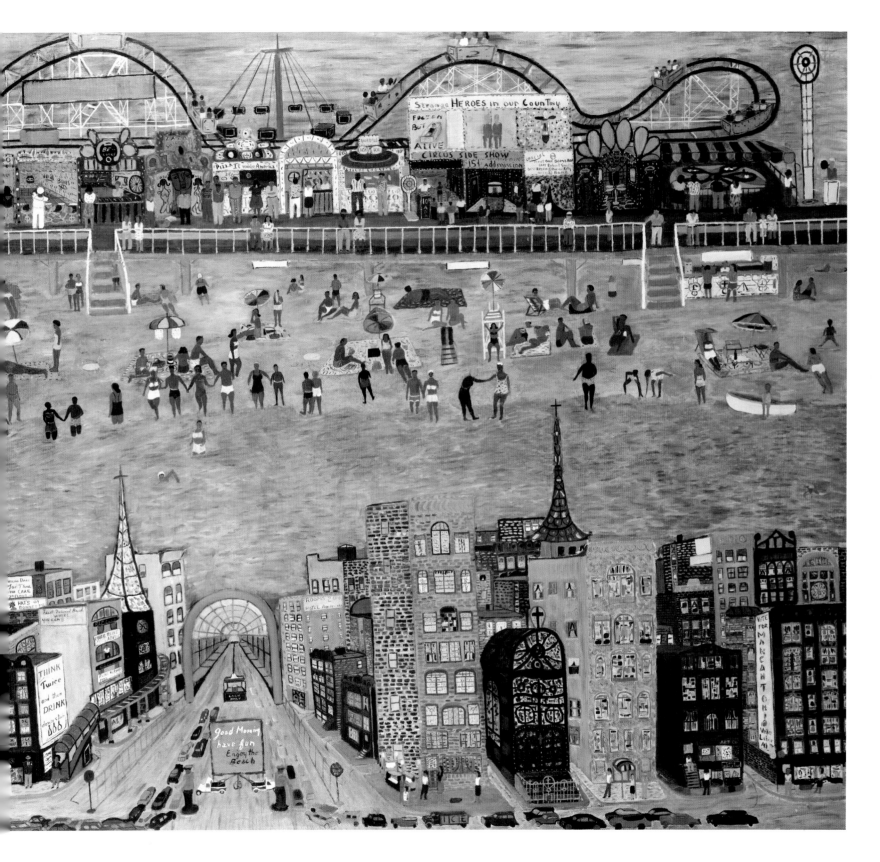

Across the River

By the late 1960s, my father had battled for decades against injustice and had become recognized as an accomplished painter. He had reached middle age, and he reluctantly agreed with my mother to move the family a bit north of New York City. He had learned from living in lower Manhattan and the South Bronx that there is an optimum density of population that is healthy for humans. He recognized that urban settings need to include natural spaces in which to rest, play, and interact, while my mother wished for her children to grow up in an upwardly mobile context. So off to Westchester County we went.

Ralph's most adept depiction of his ideal human environment is shown in *Across the River*. Combining the best aspects of the Bronx, Yonkers, and Dobbs Ferry, the painting illustrates what today's urban planners would describe as a moderate-density, mixed-use economy. Clean, animated apartment buildings are set in close proximity to small-scale industrial employment, a "small town" retail center, a nature preserve, and farmland, all made accessible by a network of roads, a rail line, and bicycle paths. It took a meandering interdisciplinary journey for me to reach my understanding of the ecosphere we inhabit and our role in it, but it began as I watched my father paint the city and its environs and immersed myself in the woods behind my childhood home.

Across the River calls to me in a spiritual way. Like so much of my father's work, it doesn't make sense in a direct, orderly manner. The composite scene, drawn from many chapters of my father's life, depicts what he considered the best aspects of our human community, his vision drawn from lived experience and what he hoped for in the world my sister and I would inhabit. Based loosely on a view he and my mother had from an apartment in the Riverside section of the Bronx, it is everywhere he had seen and wanted to be and nowhere he had ever lived.

At the base of the painting, in the foreground, sits a wall blocking out the crowded urban past of his tenement youth. Just above the wall, a young dark-skinned child stands in a playpen in the uncluttered backyard of a trim, green, nineteenth-century wood-sided home with a colorful slate roof. Above the child, the laundry of domesticity wafts dry in the fresh air. To the left of the yard is an unpaved alley and a row of small apartment buildings, all well kept, with each window providing a view into the cozy atmosphere of the inhabitants' homes. My father delighted in visiting people's apartments, taking mental notes on how they structured and ordered their lives and what colors and patterns they chose. His larger canvases often portray the details of interiors drawn from an encyclopedic memory of urban working-class lives.

To the right of the small turn-of-the-century apartments, along the same side of the street, stands a newer postwar apartment building looming over the open sky of the earlier industrial city. The newer building is outsized for the landscape but clean and well built. At the center of the painting, between the apartment buildings, children and parents of a variety of ethnicities play stickball and relax in spaces like those being created by urban planners of the time, guided by the visionary, if controversial, work of Robert Moses.[1] A highway flyover raises the speeding traffic above the road and riverfront preserved for the enjoyment of pedestrians. My father remembered rafting in ponds and playing stickball in homemade sandlot fields dug out by the parents and kids in the neighborhood on undeveloped land in the Bronx. His memories permeate the chalked-in outline of the baseball diamond in the road.

The Hudson River divides the lower portion of the painting from the suburban expanse above. The barge entering on the left indicates the flow of commerce from Albany, as well as from Beacon, Croton-on-Hudson, and Piermont, communities that Ralph's progressive colleagues, such as Pete Seeger, had introduced to him. Across the river sits a diminutive portrayal of the factories of Yonkers, Hastings, Irvington, and Tarrytown—towns where my father had worked as a union organizer. Behind the glass and steel of the industrial waterfront lie Westchester, Putnam, Rockland, and Orange Counties. These towns and counties are not contiguous and are situated on opposing sides of the river, but he has wrapped the river back and forth to unify the composition.

At the top of the painting, a bridge—the Tappan Zee or the Bear Mountain, or a representation of both—traverses the river. Here Ralph portrays the composite experience of traveling a road winding along the river and leading to scenes of unhurried life, where residents live in modest, wood-frame homes set between agricultural fields and woodlands.

Across the River, 1969. Oil on canvas, 43¾ x 35½ in. Collection of Marc Fasanella

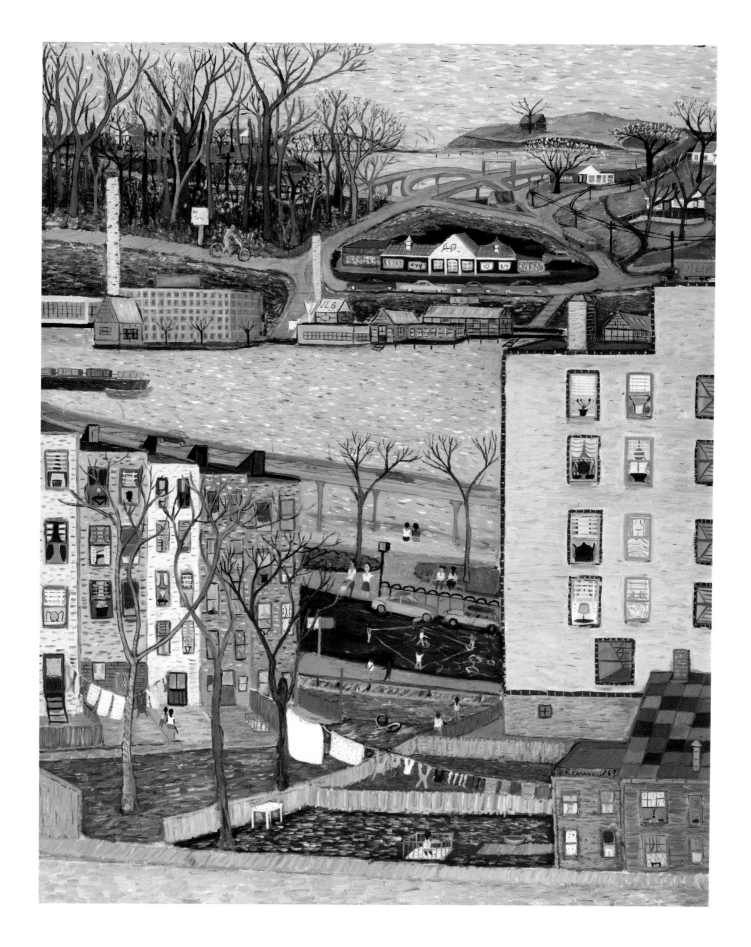

Dobbs Ferry—Railroad Tracks, 1975. Oil on canvas, 30 x 40. Private collection

My father completed *Across the River* at a significant time in his personal life. He was embracing family, he owned his own business, and he had departed from the city of his youth. His vision is prescient and clear in the painting: a future where the past remains unmolested as we delicately and thoughtfully meander into the future, as in the manner of the oversized but humble figure of a man riding a bicycle along the edge of the woods in the upper left of the composition.

My mother took charge of relocating, taking us from apartment life in the city—where my father had to store his paintings and canvases in a hallway—to the village of Ardsley, chosen for its proximity to New York City and for the reputation of its schools. We lived in three different houses in Ardsley. When my father completed *Across the River*, we had just settled in a small contemporary home on a wooded lot. This first house, on Dobbs Ferry Road, and the second, on Captain Honeywell Road, each had a cramped basement space that served as Ralph's studio. When it became clear that his work needed more space, my mother built a home with a studio for him on an improbable lot at the edge of undeveloped land. One couldn't walk anywhere comfortably—or bicycle for that matter—and the effects of moving to the suburbs weighed heavily on my father.

When my mother first moved us to Ardsley, it was truly bucolic. An old couple ran a greengrocer storefront that made deliveries, and a farm on the outskirts of the village sold homegrown produce. My sister took riding lessons and worked at a horse stable on another edge of the village, and there were several parks and a large community pool.

The acreage of wooded land behind our home included streams, ponds, and a partially abandoned estate, complete with a nineteenth-century landowner's recreation facilities in a near complete state of ruin. A swimming pool had turned a murky green over fifty-odd years and hosted a community of fish, frogs, and turtles. A large, stone indoor tennis court, with part of its slate roof fallen in, was overtaken by vines, mice, and a large rookery of pigeons. I spent as much time as possible immersed in this landscape of decay, growth, and wonder, developing an intense interest in the reptiles and amphibians that dwelled in the wood. I became expert at locating, capturing, and identifying creatures and built a collection of living specimens in terrariums at home. Though my father chafed at the loss of a dense urban community to socialize in and the intellectual discourse that city life can nourish, my larger world, as a young boy, began at the back door of his studio. My father never entered those woods—to him it was Marc's world—but he knew the value it brought to my life.

Ralph empathized with the desire to live in a place that offered fresh air, nature, and good schools, but Ardsley was a town devoid of culture, a bedroom community where people commuted to jobs in New York City and White Plains. The town provided no bookstore, no intellectuals at the bar, no art gallery, no earthy Italian food. So my father spent much of his time in the Bronx with his sister or in nearby working-class, gritty Dobbs Ferry. No doubt the suburban aspirations of my mother and the metropolitan longings of my father caused a nagging rift between them and occupied the forefront of my father's thoughts. *Across the River* is the brainchild of that particular angst and represents the duality I have felt as a cosmopolitan ecologist. As I commit myself to the unhurried work we must accomplish to repair the fabric of our communities in an eco-centric way, it is *Across the River* I call to my mind's eye. I have always kept the painting in a prominent place in my home and in my consciousness.

1 In her seminal book *The Death and Life of Great American Cities* (New York: Random House, 1961), Jane Jacobs sharply criticizes Robert Moses for his razing of entire neighborhoods in the name of urban renewal.

Dobbs Ferry Road, 1967. Oil on canvas, 12 x 24 in. Collection of Marc Fasanella

Marc in Backyard, 1974. Oil on canvas, 18 x 24 in. Collection of Marc Fasanella

Family Supper

I know so much and yet so little about *Family Supper*. Everything I do know I have heard secondhand or thirdhand from my father—the others depicted in the painting led a life I could not know. The scene reminds me that my father was born in a time when radio, television, automobile travel, refrigeration, telephones, flight, and industrial agriculture were uncommon or didn't exist. I am reminded that he came of age and lived his life throughout a period of remarkable technological and social change. And I contemplate the circumstances of this large masterwork's creation: Ralph painted *Family Supper* to vividly portray the context of his parents' life at a time when he was struggling with his own marriage.

On the left side of my grandparents' kitchen in this painting, the icebox contains homemade wine and imported cheese and is topped with fresh, locally grown fruits and vegetables. In the upper left there is a coin-operated gas meter used for cooking, heat, and lighting. My grandmother is centered in the top portion of the painting, depicted on an altarpiece looming over a dresser. She is tied to a cross by her career in the needle trades and as the intellectual and emotional center of the family, with two children clinging to her. To the right, my grandfather appears on a wall calendar, crucified as well, but by the ice picks and tongs of his trade. Along the bottom of the painting a daybed and a trundle bed sit next to the iconic steamer trunk of an immigrant family. (Two of my father's brothers had to sleep in the kitchen for lack of space anywhere else in the apartment.) In the center of the painting, my father's family is gathered around a table, with his mother as the central figure again, joined by a family friend and my aunts and uncles. They appear clockwise: Lea (with long red hair), Nick, Tess, Tom, Ralph, unknown, and Sam. In the lower left-hand corner there is an ice bucket, on which is written, "In memory of my father 'Joe'—the poor bastard died Broke—and to all 'Joes' who died same—broke."

The scene is framed by the Little Italy neighborhood where the family lived. Having visited those streets and similar apartments, I can hear the sounds of the tenement neighborhood and taste the pastries my grandmother made (though I never met her). I can feel the warmth and tensions of the family members sharing a meal, and see the light and the radiance my father put into every detail of that kitchen. Those gatherings with his progressive, intelligent, and perceptive mother shaped my father and made him an empathetic person with an ability to engage people intellectually and emotionally. His brothers and sisters were very different people, some radical and some conservative in their thinking, but he loved and understood all of them.

I marvel at how removed so many in the United States have become from a life centered around communal family meals, where life is shared, argued about, and dealt with over delicious home-cooked food purchased from local grocers. To many, *Family Supper* is a foreign image from another age, and yet it is my heritage, my home—a marriage of the basic elements of my own intellectual and emotional core. It stands for so much that I believe in, while it simultaneously seems so remote.

I believe the process of creating this painting, along with my mother's fundamental belief in my father as a decent man, held my family together. My parents built a new home in Ardsley while he was crafting *Family Supper*, and their relationship became strained to the point of separation. After a time they reconciled, and my mother became an outstanding Italian cook, a skill she had never mastered when she was balancing the demands of her career as an elementary school teacher and raising two children. The fights my parents had during my early teen years gave way to in-depth discussions over delicious meals, often with friends in attendance. Those dinners and progressive conversations shaped my identity in important and positive ways.

Family Supper serves as both a memory and a vision. Carlo Petrini, the Italian founder of the international Slow Food movement, has pointed out that we have degraded the family meal in a desire for an expedient, efficient life, but perhaps nothing is as important to the development of the human community as a nourishing family supper.

Family Supper, 1972. Oil on canvas, 72 x 50 in.
National Park Service, Ellis Island Immigration Museum

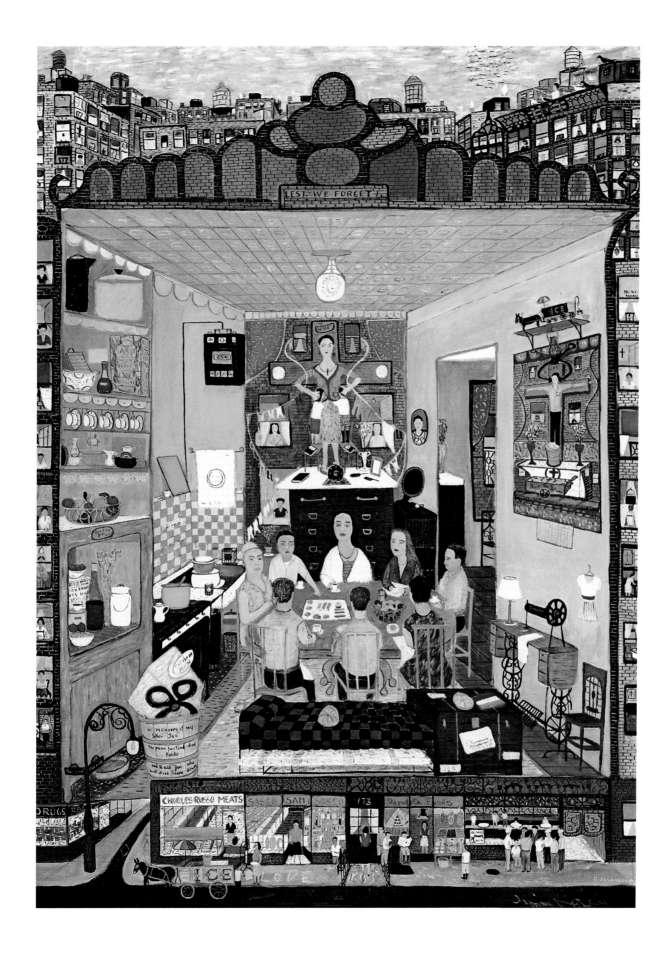

Dress Shop

My father delighted in labor. I have always found it remarkable that though he had worked as a union organizer and had a profound understanding of the suffering of the working class and the avarice of the ruling class, his memories of work experiences were positive. He enjoyed watching people at work, intently noticing the details of their movements. On many occasions he pointed out how beautifully executed manual labor was like ballet.

If one considers work—as opposed to luxury or idleness—a path to contentment and the workplace a respite from human miseries, *Dress Shop* (1972; pp. 78–79) can be considered a version of paradise. The painting's central feature is the Triangle Shirtwaist factory where my grandmother worked several years after its infamous 1911 fire. Like the Morey Machine shop in Ralph's 1954 painting *Bench Workers (Morey's Machine Shop)* (pp. 76–77), here the Triangle Shirtwaist floor is bright and cheerful, the workplace organized, spacious, and clean.

In the 1990s I was visiting an artist's studio in an industrial neighborhood in Brooklyn when I accidentally entered a textile sweatshop in the building. The working conditions were akin to those that caused the 1911 factory fire. The women working the sewing machines did not look up to see who entered the room, as, I surmised, each second away from their work was money lost. The tables at which they worked were piled high with fabric, and bins of completed textiles crowded them, leaving little room for them to maneuver. The lighting was dim and the room claustrophobically hot from the plethora of running engines and sealed windows. A profusion of flies swarmed the large piles of sheepskin being used to make leather jackets. The din of machinery and the air thick with cigarette smoke and grease choked me, and I could not imagine the effect of working day after day in such conditions. It was an intensely demoralizing and degrading workplace.

My father had told me that the working conditions of the Triangle Shirtwaist factory led my grandmother to become increasingly radicalized. The scene depicted in *Dress Shop* shows the textile factory as it should have been constructed. He considered every aspect of the workplace, from lighting to a well-displayed No Smoking sign and a fire exit where a young man—who may very well be my father when he worked at the factory—rests on the stairs. Spools of thread are conveniently placed for easy access by workers. The seamstresses sit facing each other, conversing while they work, and can walk freely about the factory floor. They appear at ease. The few men, seemingly of equal status to the women, steam shirtsleeves and move garments.

The windows on the left of the factory floor open out to a past represented by crowded, dark edifices with dim interiors. The buildings evoke a feeling of the Depression era, marked by soot, loneliness, and long expanses of time; the figures within are idle and isolated—some are mannequins. A subway entrance and an ominous stairway share the bottom left-hand corner; a sign reading No Help Wanted is posted between them. My mother sits alone in the office above the subway, typing memos at her secretarial job at Westinghouse. Only her animated face and the chalk stickball diamond, messaged with the graffiti "Giants win" and "Ralph loves Gina" (my sister), humanize the entire left-hand section. A portentous sky—spacious, turbulent, and heavy with atmosphere—looms above the crowded turn-of-the-century cityscape with its empty storefronts.

At the back of the factory and along its right wall, a series of crises is commemorated. From left to right, the first window panel is an abstract depiction of the 1911 fire that caused the deaths of 146 garment workers, 123 women and 23 men, who died from being burned, inhaling smoke, or falling or jumping from the factory windows. The next window is topped by the news headline "Nixon Slides In," with a vague pronouncement, "The people," beneath it. Following windows announce Robert Kennedy's assassination, then Martin Luther King Jr.'s, then President Kennedy's. And finally a psychedelic collage is topped by the phrase "Save America Cokes," a reference to both the Coca Cola and the cocaine that were fueling the 1970s American culture. The windows reveal the turbulent world outside while protecting the workers inside. The factory interior remains unaffected by these catastrophes and a safe space of communal effort.

Below and to the left of the factory floor a placard reads "In memory of the Triangle Shirt workers," and below it, the domestic interiors of the workers are portrayed as well-furnished, clean, well-lit, vibrant homes

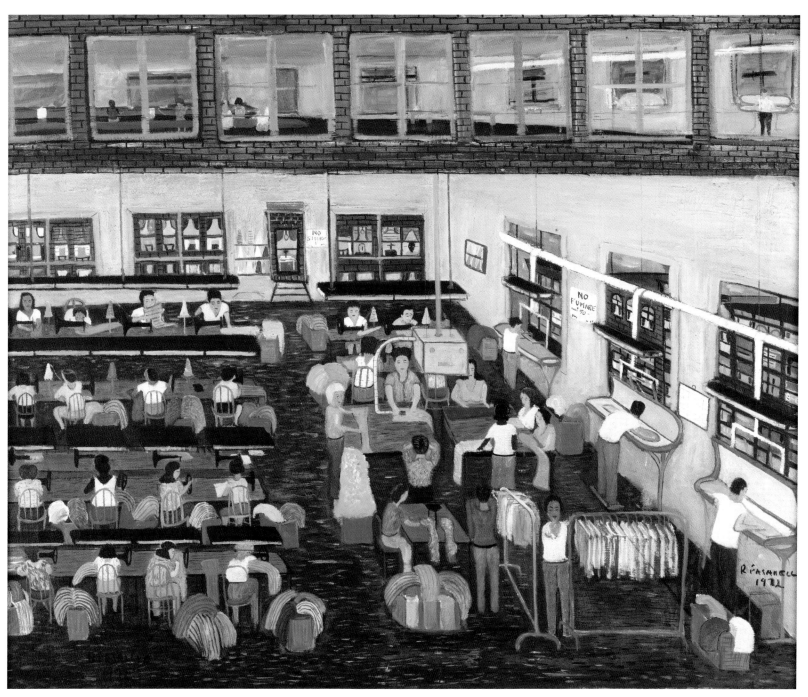

Dress Shop Study, 1972. Oil on canvas, 26 x 32 in. Fenimore Art Museum, Cooperstown, New York. Museum purchase, N0002.2014

situated in cramped apartments. The women in these domestic scenes are energetic as they cook, wash dishes, and sew their own garments, seemingly without the pressures of a work life leaving them devoid of their own time. To the right of these interiors Ralph placed a machine shop similar to the one he portrayed in *Bench Workers (Morey's Machine Shop)*. He apprenticed as a machinist after returning from the Spanish Civil War, and his work with such a factory helped launch his career as a union organizer. The interior of the machine shop in *Dress Shop* is also clean and well ordered, with large windows. Yet it is closed off from the postwar integrated neighborhood outside, where interiors are colorful and animated, with both poverty and sense of community clearly evident. Men, women, and children enliven the working-class apartments above a street cluttered with parked vehicles, an abandoned car adorned playfully with the word "love," a sports bar advertising three for a buck, and a corner dollar store. This likely depicts the Bronx neighborhood where Ralph and his partner operated the service station shown in *Happy and Bud 's Service Station* (1968; p. 80).

The center of the painting celebrates a world my father knew could and should exist, a workplace of contentment, the dress shop that society owed to the workers killed in the Triangle Shirtwaist factory fire.

Bench Workers (Morey's Machine Shop), 1954.
Oil on canvas, 34¼ x 67 in. Fenimore Art Museum, Cooperstown, New York. Gift of James and Judith Taylor in memory of Ralph Fasanella, N0110.2001

Following spread: Dress Shop, 1972. Oil on canvas, 45 x 90 in. Fenimore Art Museum, Cooperstown, New York. Museum Purchase, N0003.1983

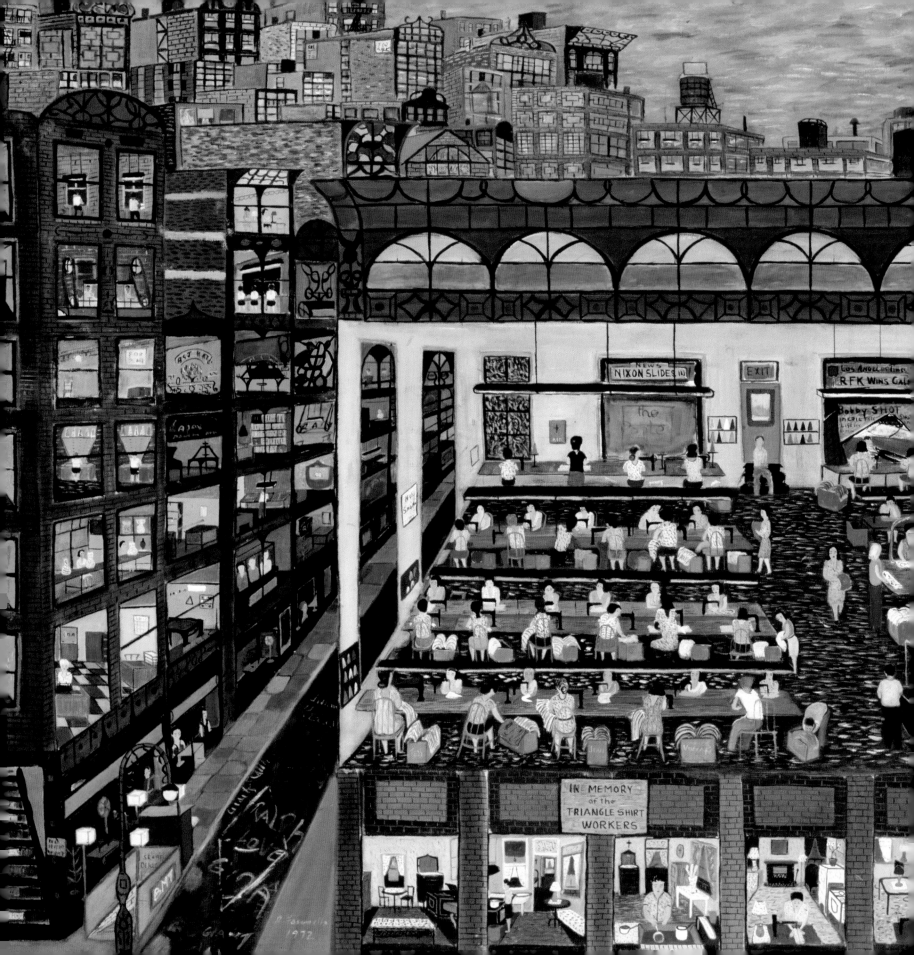

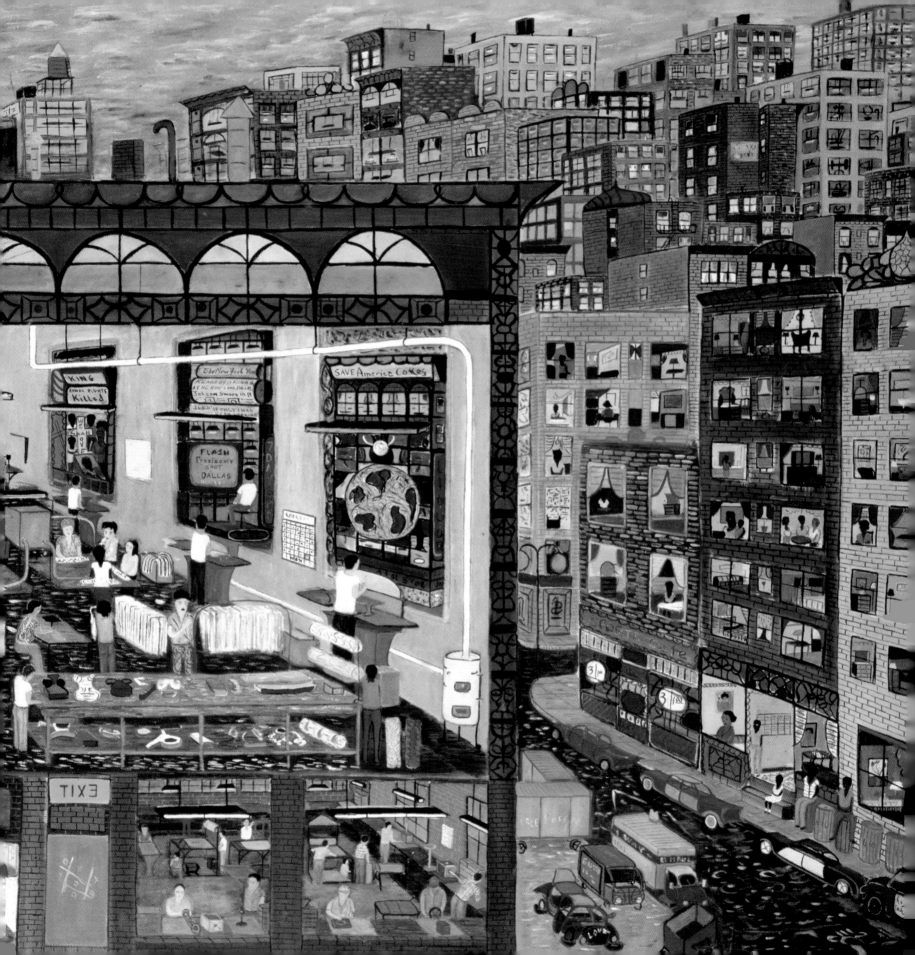

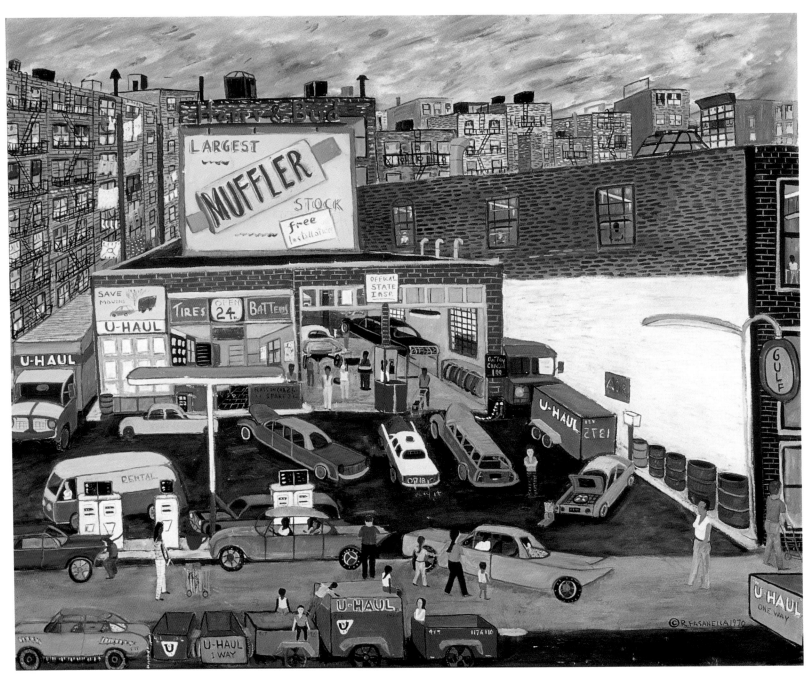

Happy and Bud's Service Station, 1968. Oil on canvas, 32 x 40 in. Collection of Marc Fasanella

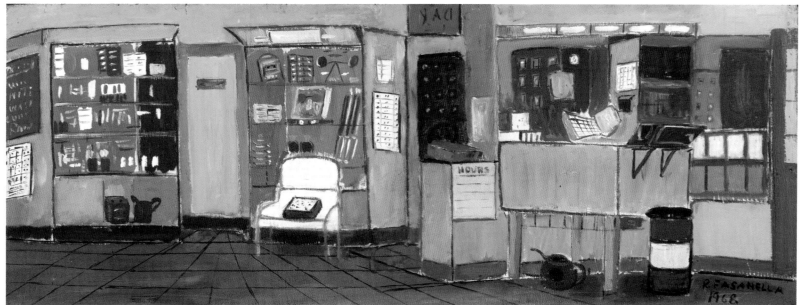

Top: *Happy and Bud's Office*, 1968. Oil on board, 9 x 24 in. Private collection. Courtesy Andrew Edlin Gallery

Bottom: *Happy and Bud's Gas Station*, 1968. Oil on board, 9 x 24 in. Collection of Marc Fasanella

Unpacking the Mills

The story goes that when my father was experiencing a creative slump, he visited Lawrence and Lowell, Massachusetts, on the advice of a friend. Truth be told, I think my parents needed some time apart. A decade had passed since we had moved out of the city to Westchester County, and my father could not stomach the suburbs. It was 1975; Ralph was sixty years old and had retired from running the gas station. Spending time in the New England mill towns with people who struggled for a living brought him back in touch with why he had become a labor activist in the 1930s, why he had fought against Franco in Spain, and why he had so much passion for the working class. He came home on weekends to see my sister and me, and eventually he brought me to the mills to see what had been engaging his mind for months, what had become his passion. He seemed to know everybody in Lawrence and Lowell, like he was a native of the towns, and he had easy access to anyplace he wanted to show me. He would greet someone with a "Hey, Moe!" With a "Hey, Ralph" in response, we would be granted free rein of the mills, some operating illegally with equipment that seemed to date from a previous century.

My father was an exceptional guy. My mother always said that if he got on a crowded elevator, by the time he reached the fifth floor he knew everyone in the car and would most likely keep in contact with at least one of them. In any situation, in any environment, he would find a way to talk to people. With workers there was an instant bond. They could tell he was one of them, a guy with dirty fingernails, a pockmarked face, a jiving sense of humor, and deep empathy and appreciation for the work they were doing. He was smart, well read, and articulate, and he wasn't going to let anyone get into trouble on his account. Management knew it was better to give him free rein than to find a reason to prevent him from seeing what he wanted to see. What was the harm in letting a working-class artist wander around, talk to people, and sketch?

So, as an adolescent I walked the floor of the mills, met the workers, experienced the deafening noise of textile factory machines and the exhausting pace of industrial production, and breathed in air thick with cotton dust, oil, and sweat. I felt the massive scale of brick buildings weigh on me, the years of toil worn into the floorboards beneath me. We spent hours that blended into days studying the mills, their architecture, the networks of canals used to power the booming nineteenth-century textile industry of Massachusetts. The noise and the heavy air that permeated my skin remain within my memory today.

When I studied art and architecture in graduate school, I thought it would be important to construct an installation that could expose the visceral, wearying, and enervating experience of work in the mills to museumgoers, but I was also drawn to the beauty I saw in the inanimate components of the mill: the endless expanses of brick wall punctuated by a repetitive pattern of huge windows and massive beams or posts, the well-worn machines and the ingenious design of their interchangeable parts. I drew floor plans and elevations, selected materials, and conceived of an audio experience. (My installation never materialized.) I had observed all of the same darkness as my father did, but where I saw a relic he perceived a living opera populated with a cast of engaging characters whose lives he wanted to know. His senses were alive and open to every vibration. He could absorb every last detail of the factory as a collective entity as well as appreciate each and every soul who occupied it. He loved them in the same way he loved me. He wanted to know their stories. In just the briefest of moments he could engage them, making them chuckle and offering his thoughts as he listened to theirs. He so enjoyed their company, he often invited them out for coffee or to share a cigarette. He could spend the day talking and sketching obsessively. His hands were an extension of his eyes, ears, nose, and throat— they helped him perceive. The thousands of sketches he produced were moments of reflection and analyses of the ways people were sitting, how energetic or tired they looked, how much of life was recorded in their hands and their shoes, how they occupied the space around them.

My father saturated himself with the environment of the mills and their workers. His many years as a union organizer and activist drew him deeply into the study of their history: the struggle for a worldwide union in the form of the Industrial Workers of the World, as well as the 1912 Bread and Roses textile strike in Lawrence, which was remarkable in its ability to bring together immigrant workers from so many disparate cultures and for the prescient placement of women at the head of the picket lines and in leadership roles. He made every effort he could to analyze

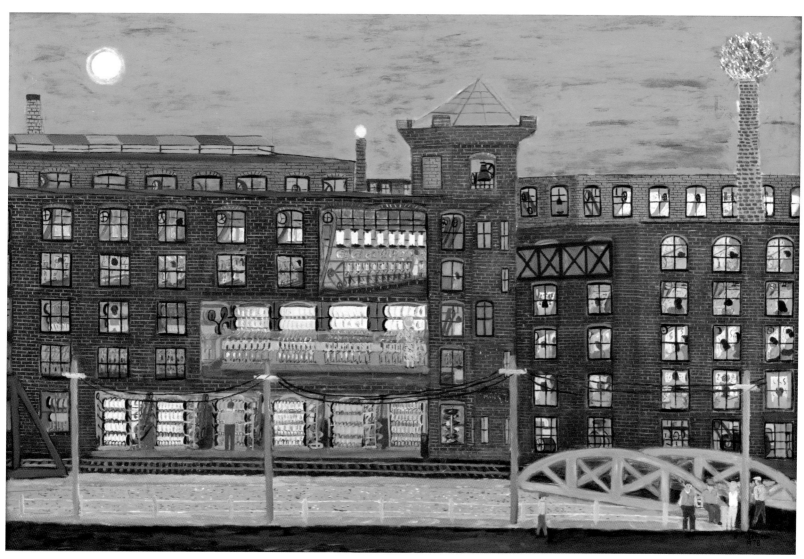

Mill Workers—Night Shift #2, 1976. Oil on canvas, 36 x 54 in. Courtesy Andrew Edlin Gallery

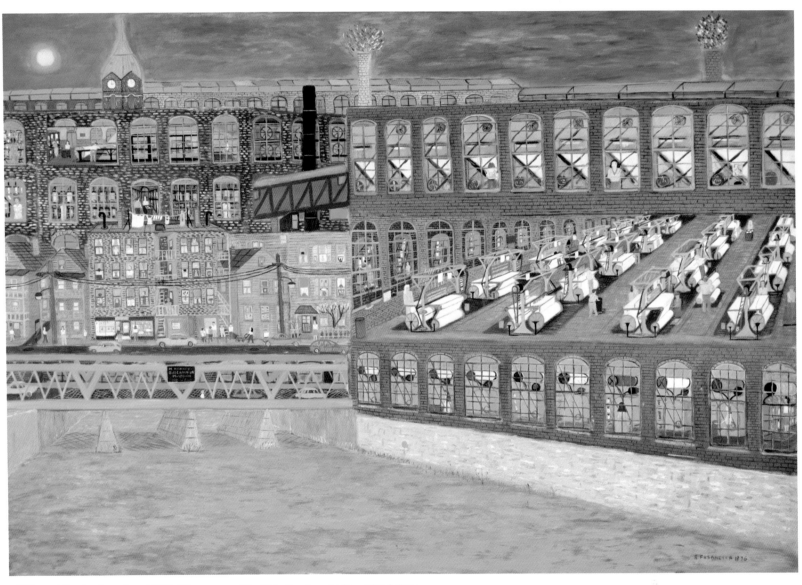

Mill Town—Weaving Department, 1976. Oil on canvas, 50 x 72 in. Courtesy Andrew Edlin Gallery

and record the many the salient elements of the momentous changes that took place during 1912. He spoke for countless hours with current mill workers, retired mill workers, and the children and grandchildren of mill workers, and with historians, politicians, and the owners and staff of the eateries where these people congregated. In the same way that he painted—feeling his way forward, letting the evolution of the canvas reveal new insights to him—he started assembling materials. His studio became cluttered with books about Lawrence, Lowell, and the history of the labor movement in Massachusetts. He met historians, folk musicians, and songwriters who knew the stories and songs of the picket lines from 1912; he brought home their recordings and listened to them repeatedly. Into the studio came spools and bobbins, copies of articles, photographs, etchings, political buttons, and banners—any ephemera he could put his hands on and stuff in his pockets that connected him with his experiences in the mill towns.

And then he began to paint. He stretched large canvases eight feet across, and then even larger ones, the biggest he produced in his lifetime. They had to be big to contain his thoughts, to record the history that he had so clearly formed in his mind's eye. He primed his canvases with gesso and drew large, dynamic abstract compositions with charcoal. They didn't make any sense to me at the time, but, looking back, it is clear that he had absorbed and understood much of the abstract art that was the vanguard of his day. He knew how to craft a dynamic allover composition; he could convey space and time, but pure abstraction just wasn't his art. He needed to include narrative.

Ralph filled in the charcoal compositions with washes of brick red, turquoise, and yellow umber, and he began to work up the details of the strike and its people one by one: the important buildings, the canals, judicial system, commons, mill workers, security guards, strikers, and National Guardsmen. He packed as much as he could into each large canvas, altering the perspective and the scale as necessary in order to tell the story. His motifs are similar to the stained-glass windows that haunted him from his internment in the Catholic protectory, but where the church windows were often singular in their message, his canvases were multifaceted; where the stained glass offered a moody respite from the darkness and sins of the church, his paintings were bright and full of air, inspired by the French impressionists. He worked on several canvases at a time, and when he was stuck on how to resolve a particular aspect of a large encyclopedic panorama, he set it aside and painted smaller, more peaceful scenes of solitary buildings and their looming, melancholy presence in the night sky.

After his experience in Lawrence and Lowell, Ralph spent some time in the North End of Boston. He met wonderful people and became a fixture in the local cafés and union halls, but he never found the compelling truths he relished from his experiences in the Massachusetts mill towns. As the political winds brought the country into the Reagan-Bush era, my father searched for a firm footing while the struggles of his time became anathemas. The luncheonettes were overtaken by food franchises, and new methods of communication and retailing began to take hold. My father strove to incorporate these changes into his paintings, but the stories did not have the depth, the force, the universal meaning encapsulated in *The Great Strike (IWW Textile Strike)* (1978; pp. 86–87). Though he painted many small, beautiful paintings after his time in Lawrence, in the last two decades of his life he wrestled with the formation of his last two large canvases.

For a Spanish Civil War painting he never completed, he sketched a composition on drawing paper, stretched a large canvas, drew a charcoal composition on it, and then stopped. He chronicled the Reagan years in a large canvas titled *Ron's Rollin'* (1985; pp. 90–91). The painting is dynamic and filled with visual metaphor, but it feels unresolved, with simple colors that produce a somewhat flat sense of depth. For a painting about the collapse of the Soviet Union, he created a large triptych, but its minor details were finished by an assistant after his death. The Lawrence series remains some of his most important work and the largest body of work created around a central theme. In the Lawrence period, he was decidedly his own man, released from the demands of earning a living and surrounded by working-class and progressive, free-thinking people. He could truly follow his muse, be wholly guided by his insights, and let his powerful sense of perception draw him into a period of intense intellectual development and production.

On those trips with Ralph to the mill towns, I observed him conduct his research, and I watched him paint. I came to know who my father was—beyond his role as parent. I spent unstructured time with him, listening to him speak to people. The way he utilized all of his senses and put his perceptions on canvas opened my mind to the aesthetic, intellectual, emotional, and sensuous depth of the world around me. I learned how to use not only my eyes and ears to observe but also my nose, tongue, fingers, intellectual curiosity, reasoning, and emotional senses—my belly, as he would say. These are skills that have enriched my life. They can bring as much melancholy as they do joy, but they provide great depth to what can otherwise be a very shallow existence.

The mill series remains relevant to the present day, to the human condition. Its stories outrage, inspire, enliven; they give cause for continued activism as well as celebration. If life is to be more than just a struggle for daily bread interspersed with brief moments of material gratification, if living is to be imbued fully with the sensations brought by smelling the roses and feeling the sting of the thorns, then we need art; the human community needs to live a more complete, artful life. We need not only bread but roses too.

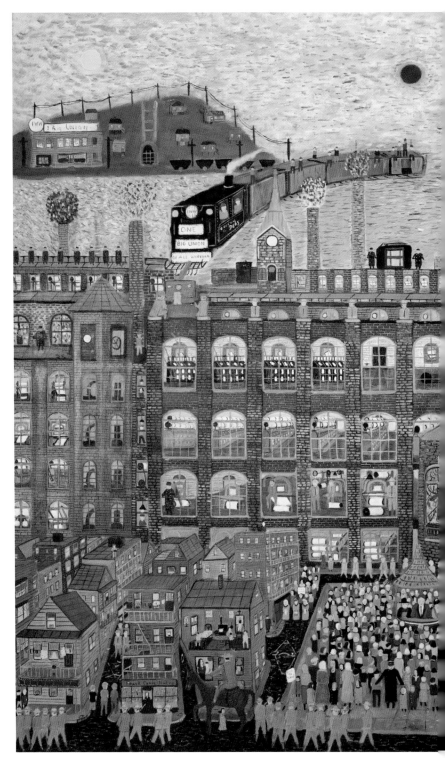

The Great Strike (IWW Textile Strike), 1978. Oil on canvas, 65 x 118 in. Building and Construction Trades Department, AFL-CIO, Washington, DC

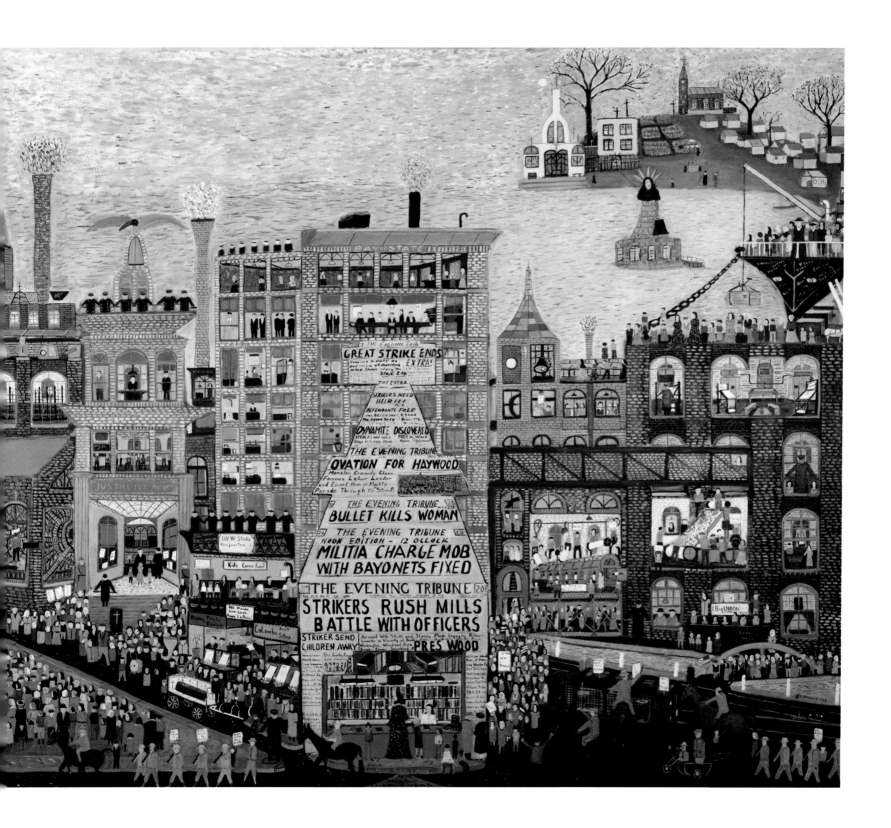

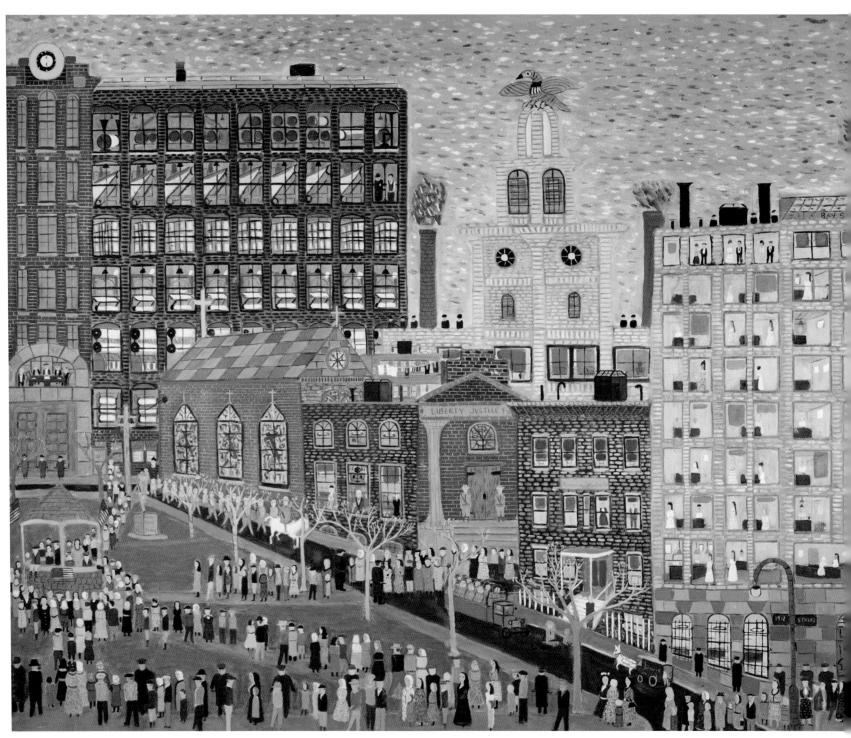

Meeting at the Commons—Lawrence, 1912, 1977. Oil on canvas, 50 x 120 in. Private collection

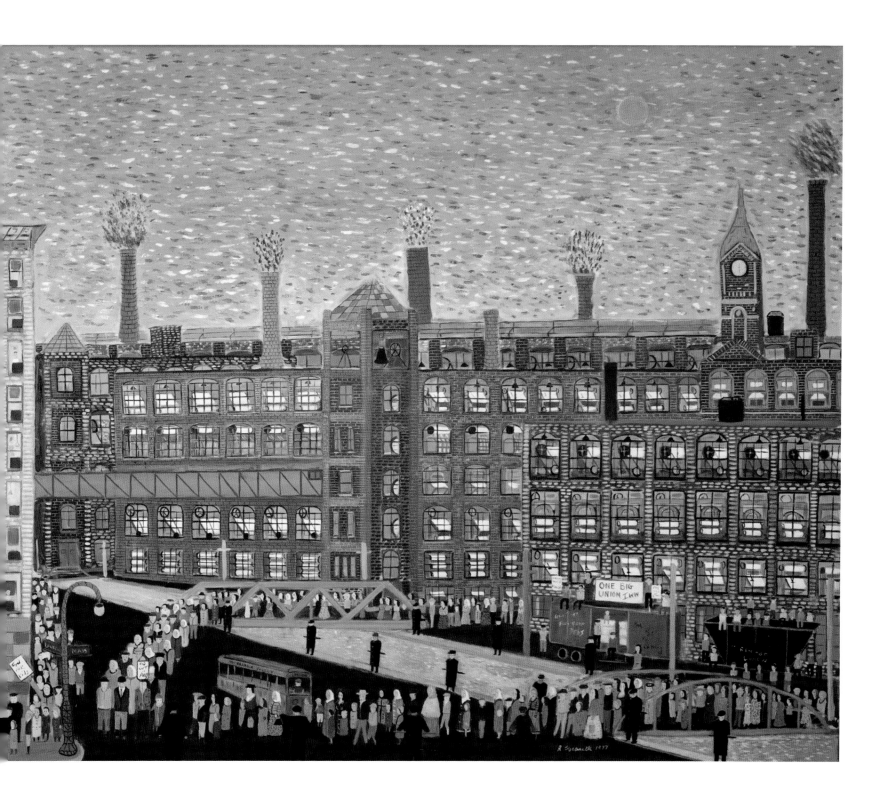

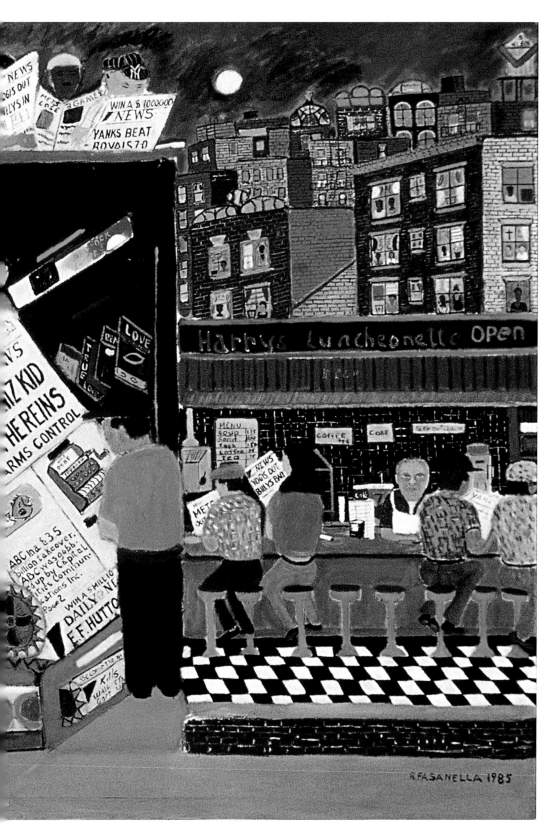

Ron's Rollin', 1985. Oil on canvas, 50 x 90 in.
American Folk Art Museum, New York. Gift of
Eva Fasanella and her children, Gina Mostrando
and Marc Fasanella, 2005.5.2

Cabin in the Woods

The demands of my parents' lives—my mother teaching first grade full time and serving as a homemaker, my father running a gas station in the Bronx all day, pursuing his passion for painting after work and through the night—must have put pressure on them both that eventually proved unbearable. I remember after we moved into our new house on Chester Street in Ardsley, which my mother had designed around my father's studio, there were nights when they would fight for hours. On the weekends my mother would take my sister and me out for breakfast, to a park, to see a movie—anything to distract her and us from the turmoil at home. The mill paintings were conceived during this time. But when my father began to stretch canvases in his studio and paint the series, something shifted in their marriage. A string of solo exhibitions, a front-page story in *New York* magazine, a beautifully produced, fully illustrated book about my father's work by a major publisher, and perhaps a newfound sense of financial security for my parents led them to work things out. It may be that my father's meditations on his own broken family history or my mother's renewed excitement about his creative abilities provided additional glue to what was always an intellectually passionate relationship. The fighting stopped.

On the advice of some friends, my mother decided to get the entire family out of our normal routine and bring us to a campground on Lake Damariscotta, Maine. My urban parents were not about to have all four of us huddled in the rain under a canvas tent, sharing a spider-infested outdoor shower, so my mother rented a small lakeside trailer home at a campground each summer for a few years, and later, a cabin just up a hill from the lake. They were long vacations, lasting as long as six glorious weeks, and I was in my element. My mother rented a rowboat with a small motor for me, and I spent from dawn till dusk investigating the shoreline of the long lake and the uninhabited islands within it. At night there were woods to explore with other children; night crawlers, frogs, and toads to catch; owls to see; and bears to fear.

My father was remarkably at home during our Maine vacations. He had done plenty of camping during his stint as a volunteer in Spain, and he made his first drawings on a trip to the country and a stay in a log cabin when he was about thirty. My parents also spent their honeymoon along a New York City waterfront when there were still undeveloped areas of shoreline that boasted small summer cottages. Ralph waded into the water and gathered all the clams and mussels he and Eva could eat. They had also spent several summers enjoying the company of fellow leftist intellectuals at Arrowhead Ranch in upstate New York. Ralph was not a stranger to the country after all.

Our trips to Maine moved him to produce beautiful folk paintings, returning to the impressionist style he had used in the study *Dobbs Ferry Road* (1967; p. 70). In the earliest Maine paintings, my family appears as part of a large group on the water's edge. Ralph also captured me in my motorboat setting off to go fishing. In many of the canvases, he portrays himself sitting with a sketchpad on his lap, watching people enjoy the bucolic woodland lakefront scene unfolding around him. This was true to life, and often a small gaggle of kids (there was an ever-changing number at the campground) would gather around him to watch him work. To them, seeing the scratchy lines he set to paper evolve into a completed scene was magical.

By 1979 we had moved to the cabin a bit farther from the lake, and Ralph painted us in a wooded setting. In *Cabin in the Woods* I sit on a stone ledge at the left, my sister on another, far to the right, and my mother at a picnic table in the middle of the scene. In 1980, on the advice of new friends from Dobbs Ferry, the Cosentinos, my mother decided we should visit Camden, Maine, instead of Damariscotta. It would be our last trip, and the painting *Camden, Maine* (1980; p. 97) captures the solitude we all felt there, showing my mother, my sister, and me looking off to the sea while the Cosentinos talk in the cabin next door.

Over the years, and after several of those long summer vacations, my father developed a love for the woods and the sanctuary they could provide. He studied the impressionists more fervently than ever and learned how to depict nature. Vincent van Gogh became a more complete muse, and it is my father's folk paintings of Maine that represent his most peaceful thoughts.

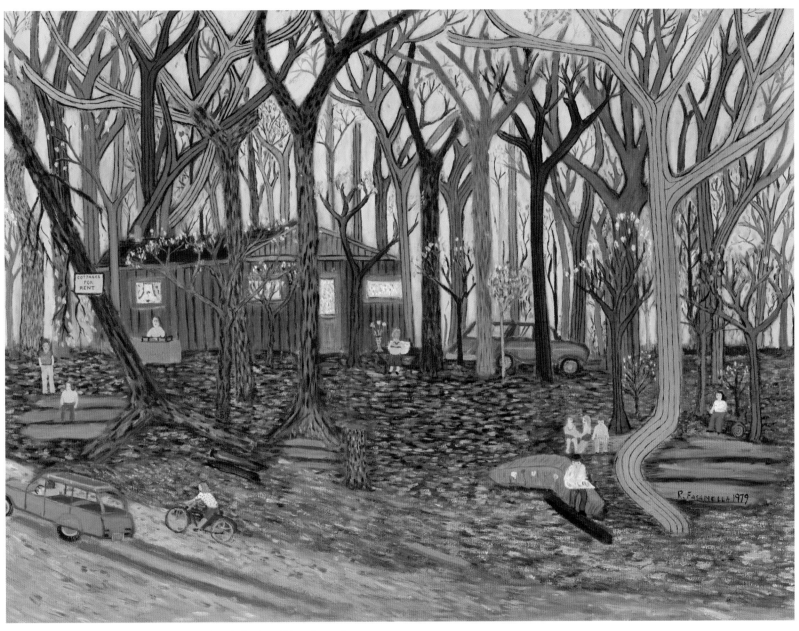

Cabin in the Woods, 1979. Oil on canvas, 30 x 40 in. Collection of Marc Fasanella

Peach Lake, 1977. Oil on canvas, 28 x 36 in. Collection of Marc Fasanella

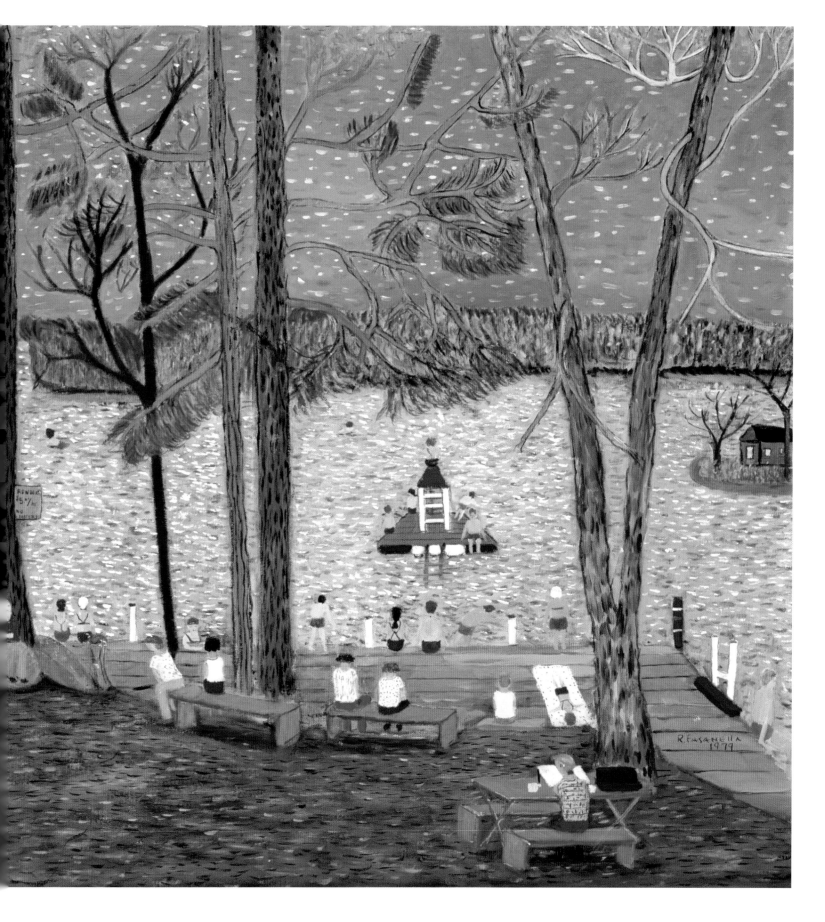

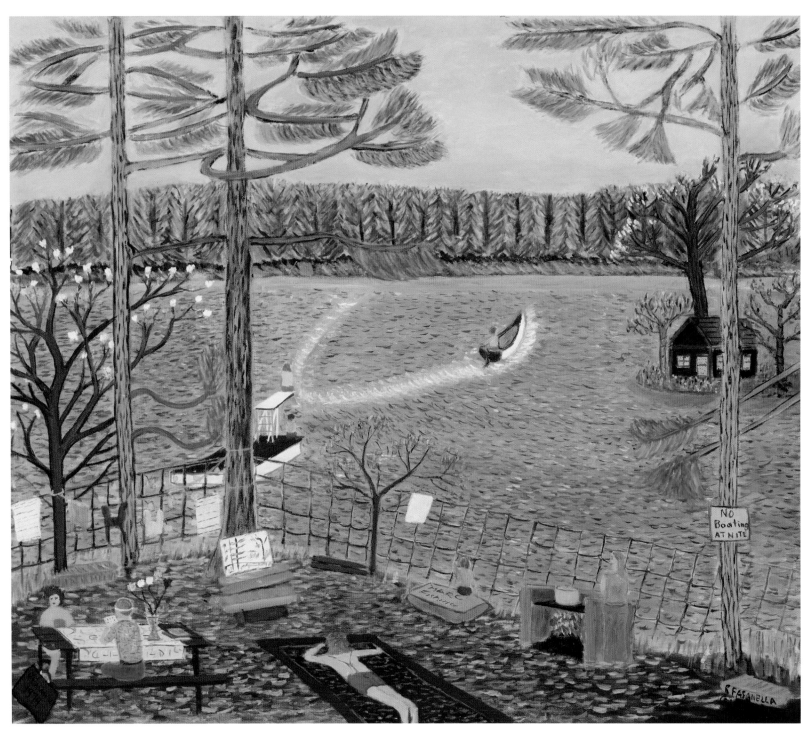

Marc Fishing, 1978. Oil on canvas, 26 x 30 in. Collection of Marc Fasanella

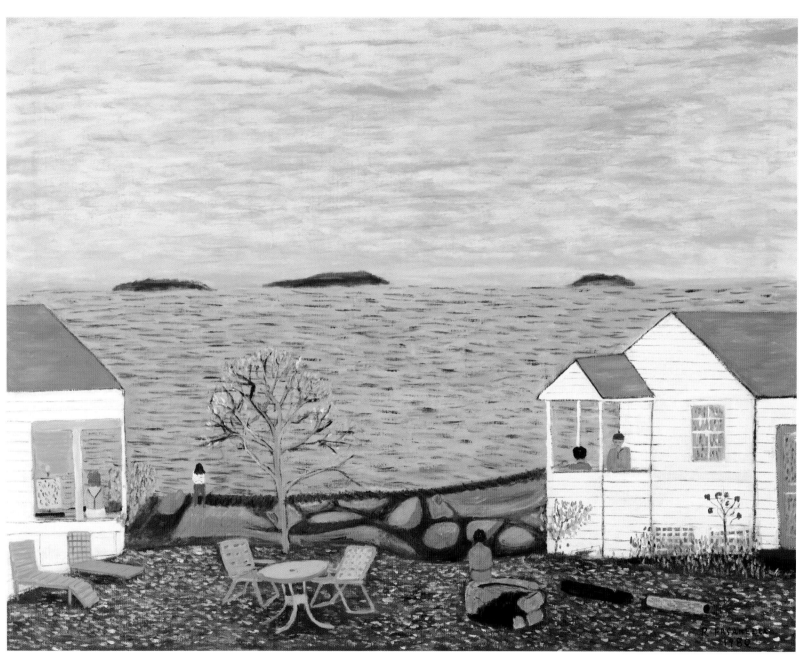

Camden Maine, 1980. Oil on canvas, 28 x 36 in. Collection of Marc Fasanella

The Old New Neighborhood

To my father, Dobbs Ferry was an ideal community, a river town composed of modest storefronts with two or three floors of apartments above. The backs of the apartment buildings opened onto small, grassy yards adorned by clean laundry drying on the line from upper stories. He spent countless hours in the Dobbs Ferry diner with his friend Dante Puzzo, who held a PhD in European history from the University of Chicago and was a full professor of history at City College of New York. They met regularly and discussed fascism in Europe, the development of the labor movement in the United States, the advent and unfolding of the civil rights movement, the Vietnam war, and the progressive ideas of the beats, hippies, and farmworkers of the day.

For as long as I can remember, Dante and my parents' friends from the labor movement were the relatives of my holidays. Each Christmas, Easter, and Thanksgiving would host marathon political discussions over traditional holiday meals. (I had no notion that a party could be an apolitical, non-intellectual affair until I attended parties held at other people's houses in high school.) Dante lived with his wife, Pat, and their daughter, Mary, in a brick townhouse in Dobbs Ferry, and a steady routine of family dinners rotating between the two homes began after Mary and I became a couple in 1980.

Over the years a few other places became favorites for my father, but Dobbs Ferry was very close to the quintessential community he imagined in his much earlier paintings. Its ethnic Italian American flavor reminded him of his youth in Little Italy, especially its stucco storefronted main street built by immigrant entrepreneurs. Dobbs Ferry had a cultural dynamic fed by proximity to the city and a location on the railroad line along the Hudson, offering a short commute to Manhattan. Ralph enjoyed a regular routine of visits along the main street, starting with breakfast conversation with Dante and diner owner Frank Otero. Next he would stop to see his friend Tommy Neill, a left-wing intellectual who lived a pleasant walk down Cedar Street toward Main, and then he would visit the public library on the corner of Cedar and Main to catch up with the staff and the town historian. A few doors south, on Main, he would chat with the tailor, an immigrant from southern Italy who hung a portrait of Mussolini in his shop. Further on, he could stop in for lunch at Sam's Italian restaurant and continue on to catch up with Frank Scioscia at the Riverrun bookstore. On the way back to the car, he'd treat himself to an espresso and pastry at a café run by a recent immigrant from Italy.

One of my father's most accessible streetscape folk paintings is *Old Neighborhood* (1980; p. 100), presenting a wonderful mix of the best of the old with the flexibility of the new. A wide asphalt street at the center of the painting is populated by a stickball team and a crowd of townspeople watching the game, shooting craps, enjoying a coffee and conversation, or taking children out for a stroll. The street intersects with a dirt road, at the center of which stands my grandfather's horse and wagon, stopped in front of a wood-frame apartment building. The details of the dress and furnishings reveal both the nineteenth and twentieth centuries, combined into one cohesive, holistic community—unlike his previous canvases where eras of time were depicted on opposite sides.

The shop on the left of the central building is Russo's Real Estate. The same name, Russo, appears in *Family Supper* (p. 73) on a Charles Russo Meats storefront. The other beautiful wood-frame buildings, so common in many American turn-of-the-century towns, animate the landscape. A detail in the top left of the painting is symbolic of my father's past—the young men on the rooftop of the blue building are flying their pigeons, a hobby of Ralph's tenement youth, also depicted in *Iceman Crucified #4* (p. 53)—but farther to the left he has included Frank Otero's house in Dobbs Ferry. *Old Neighborhood* tells the story not only of Ralph's neighborhood of his teenage years at 216th Street in the Bronx, but also a version of his spiritual home, a mix of old and new, immigrant and cosmopolitan, commercial and residential, as inspired in part by Dobbs Ferry. This Ralph Fasanella community is one Jane Jacobs and new urbanists of today would recognize as their own archetype, a model of what a neighborhood should be.

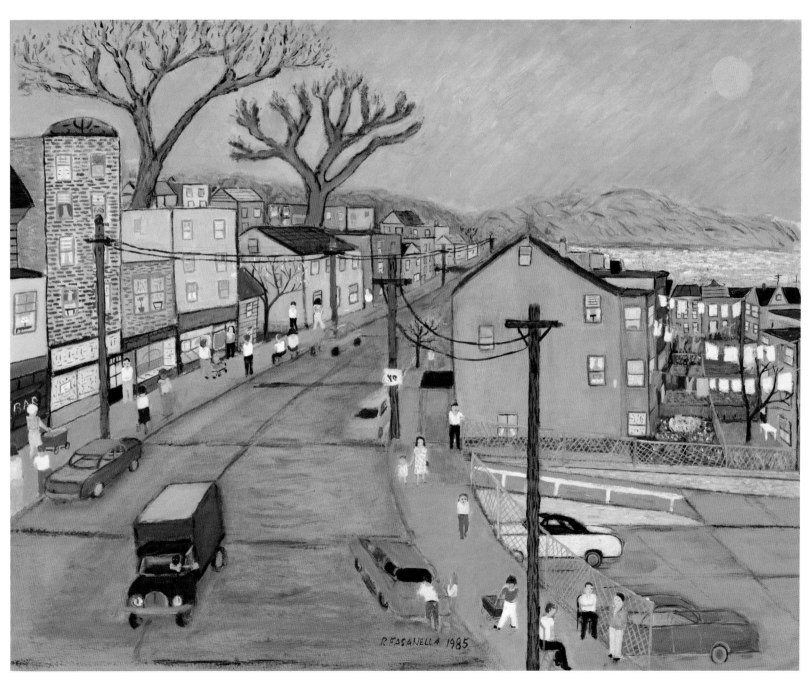

Main Street: Dobbs Ferry, 1985. Oil on canvas, 24 x 30 in. Collection of Marc Fasanella

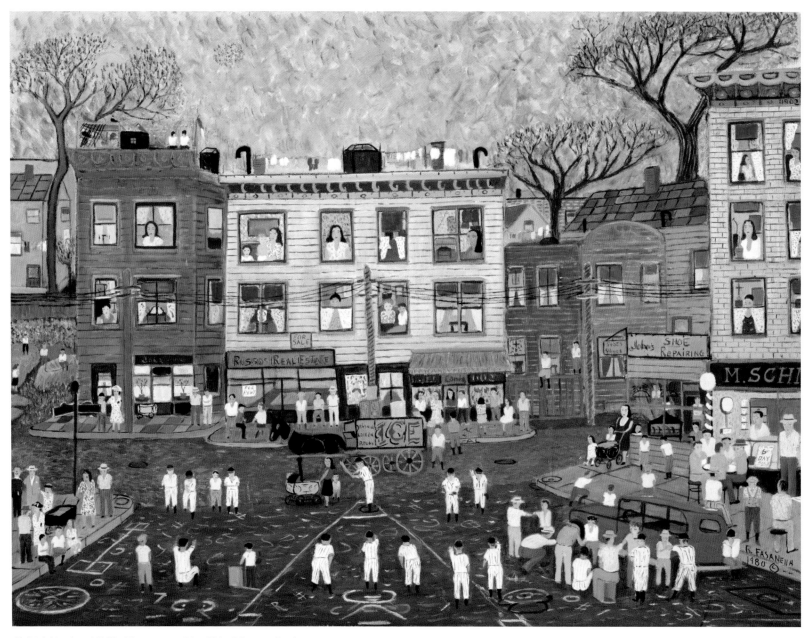

Old Neighborhood, 1980. Oil on canvas, 30 x 40 in. Private collection

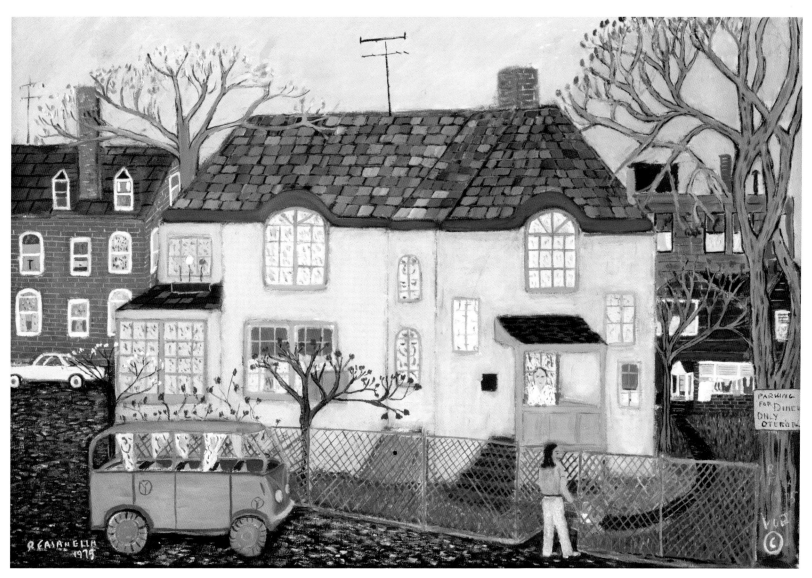

Otero's House, 1975. Oil on canvas, 22 x 32 in. Private collection

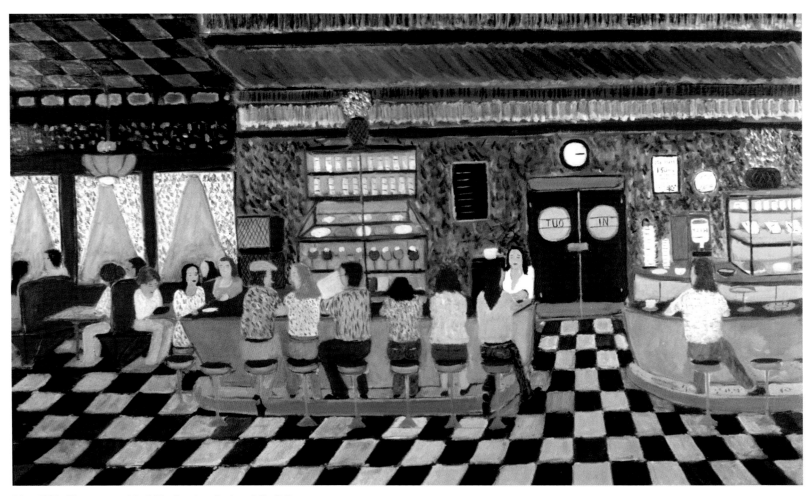

Diner, 1980. Oil on canvas, 22 x 36 in. Courtesy Andrew Edlin Gallery

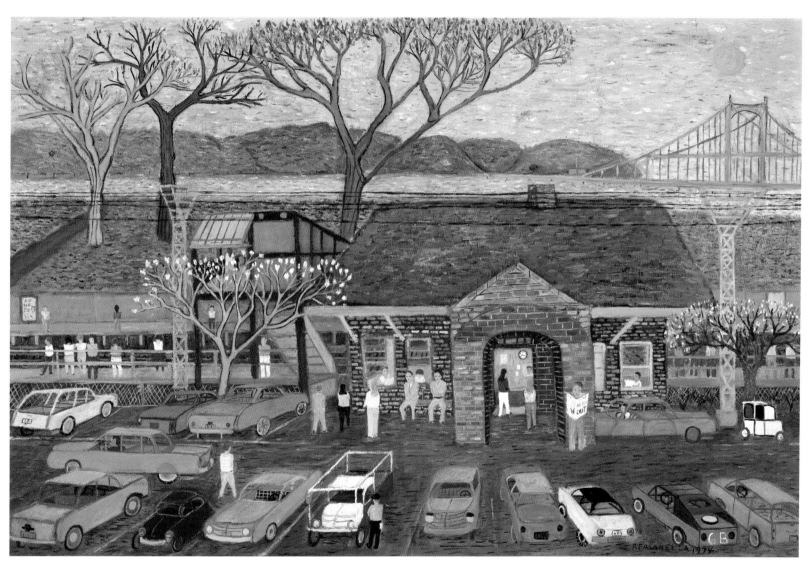

Dobbs Ferry Train Station, 1974. Oil on canvas, 24 x 36 in. Collection of Gina Mostrando

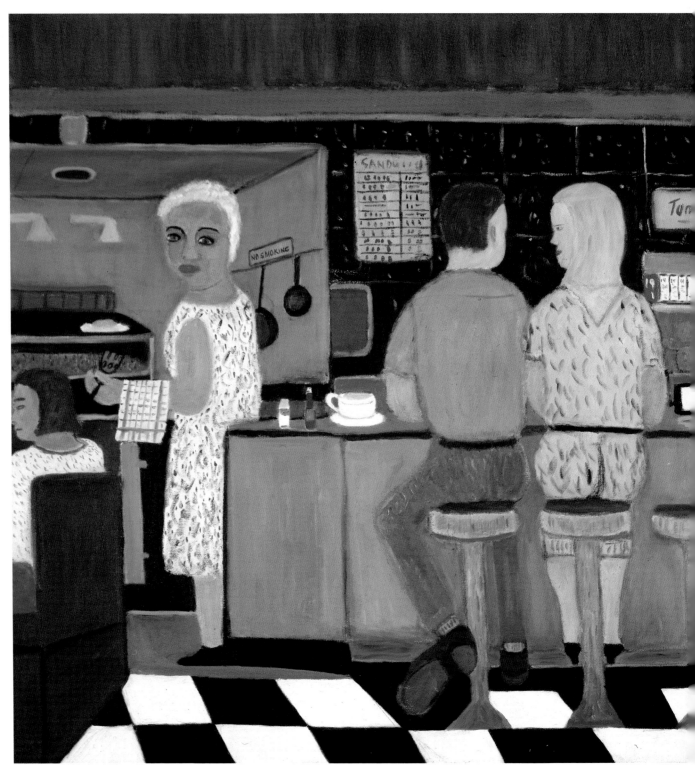

Luncheonette, 1987.
Oil on canvas, 28 x 60 in.
Private collection

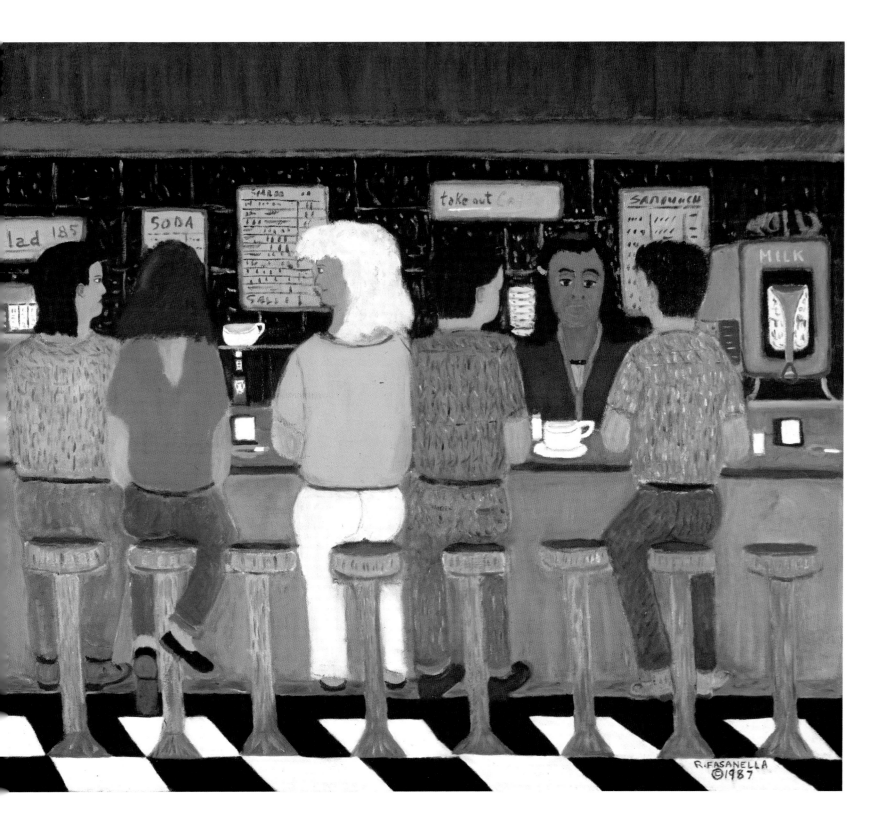

Coffee Break

In 1974, my father's internal world was in turmoil, with his marriage strained and most of his time no longer spent running a gas station. He painted an interpretation of his mental state. In *Coffee Break*, he sits larger than life, contemplating a cup of coffee at a counter as a diminutive woman beside him focuses on her reading. The left-hand side of the painting memorializes the now nearly empty, dilapidated shirtwaist factory of his youth. A news crew has arrived with cameras and lights in a vehicle bearing the logo of an all-seeing eye to cover a lone protester, who has scaled a construction waste chute with a placard to garner their attention. At his feet, children play among the detritus of urban poverty on a street cordoned off by the police as unsafe. Abandoned cars, shipping containers, and mattresses litter the street. Neighborhood residents look on as an evicted family begins to leave, their belongings loaded into a trailer. On the right sits a building that is part stark tenement housing, part museum of modern art, and part art and dance studios like those established in Harlem in the 1970s. Above Ralph's head is a frieze depicting (from left to right) Andrew Goodman, Michael Schwerner, and James Chaney, three civil rights workers who had been murdered a decade earlier while working to get out the vote during the Freedom Summer campaign in Mississippi. The painting also reflects a time when the city was set to declare bankruptcy. A year after *Coffee Break* was completed, President Gerald Ford announced that he would veto any bill that would have the federal government bail out New York from its financial crisis. The *Daily News* ran the story the next day with the headline, "Ford to City: Drop Dead."

A few years later and essentially in this context, I took a trip with my father to the Bronx to visit his sister Tess and to stop by the gas station he had left behind in order to paint full time. For the past few years we had been going to see Tess, but this would be our first visit to the gas station. The atmosphere of Tess's apartment was energizing, filled with light, my father's art, books, working-class politics, and communal meals. Tess and her husband, John, lived in a multistory postwar brick building on a densely populated street of apartment houses. For many years it was an urban utopia for her: my cousins Genie and Andrea could walk home from school; Tess and John were friendly with the retailers in the neighborhood; the Bronx Zoo and the New York Botanical Gardens were close; and the woods, fields, and farms of Westchester County were a short ride north. But by the early eighties, the neighborhood had changed: small industry had moved out; people were cramming into substandard spaces; the streets were becoming less friendly; the stores were absentee-owned. What my father and Tess had left behind in the tenements of their youth had encroached on the Bronx neighborhood.

When Ralph and I arrived at his old gas station, it was clear the transformation was complete. There in front of us sat an abandoned building, with crack cocaine being sold openly in a parking lot full of loiterers craving the open space. When we arrived home, my father went directly to his studio and began painting *Gas Station Playground* (1983; p. 108).

I had stood in front of his old station and seen the desolation of an urban setting gone awry, but he depicted the emptiness of the building and the carelessness of the loiterers as a playground. Where I saw vandalism, he saw expression; where I saw the degradation of the human spirit, he saw the struggle for a communal existence. *Coffee Break* and *Gas Station Playground* are disturbing paintings—as is *Fun City* (1980; p. 110)—but unlike his early work that deals with the deprivations of city life through the depiction of barren, darkened streets viewed from a remote perspective, these later paintings evoke a hopeful mood. The people and objects in the foregrounds, though dwarfed by their settings, animate the scenes. In *Gas Station Playground*, the buildings grow denser and more and more devoid of life as they rise above the horizon, but the cigarette billboards playfully enliven the high rises. The skies in *Fun City* and *Gas Station Playground* have both a sun and a moon, and we are not sure if we are witnessing dawn or twilight.

It is clear that Ralph had resolved his angst exhibited in *Coffee Break* and had been bolstered by the animated quality of the colors, textures, and sounds that were developing in the eighties. He found the graffiti delightful, the multihued community beautiful. His vision for the better world he knew could exist in the *Old Neighborhood* (p. 100) of the future was back in focus.

In early 1974 the union organizer Ron Carver had seen one of my father's exhibitions and was struck by the profundity and eloquence of the paintings. A decade later Carver met my father, and Ralph suggested that he visit his current exhibition at Hostos Community College. Carver drove home wishing he could bring a few Fasanella paintings to New Bedford, Massachusetts, where he was a union organizer, to share them with his union local membership. My mother advised him that Cornell University was curating a traveling exhibition, *Urban Visions*, of fifty

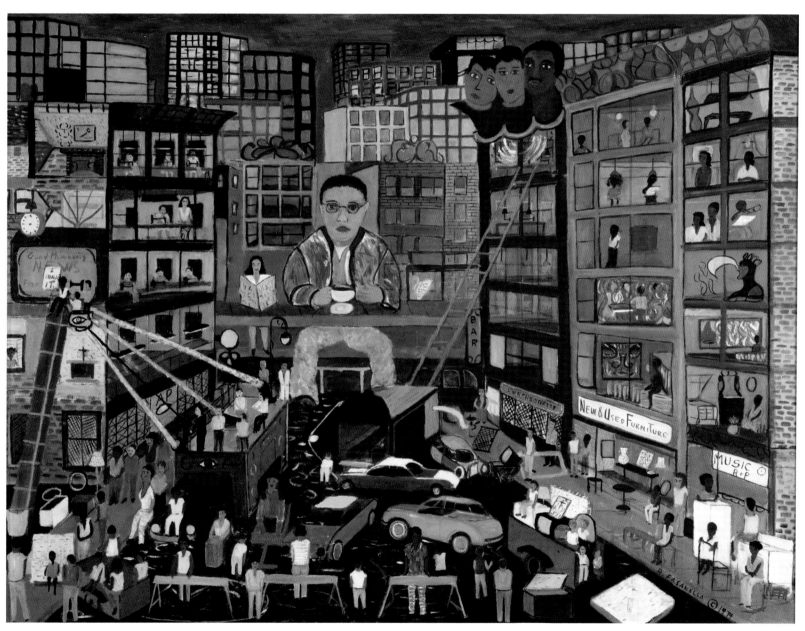

Coffee Break, 1974. Oil on canvas, 34½ x 44½ in. Fenimore Art Museum, Cooperstown, New York. Gift of James and Judith Taylor, N0016.2002

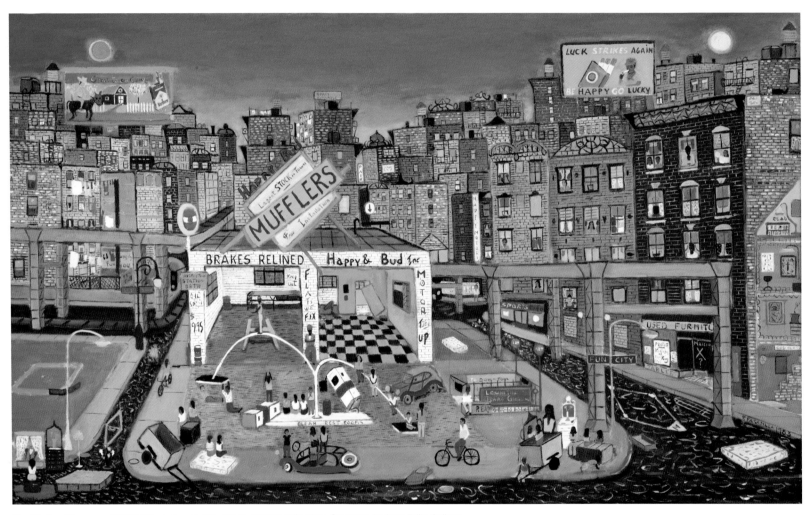

Gas Station Playground, 1983. Oil on canvas, 36 x 60 in. Private collection. Courtesy Andrew Edlin Gallery

Fasanella paintings, and Carver arranged for the exhibition to be shown in New Bedford in 1986. Just after the opening, my father informed Carver that his gallery was selling his 7½-foot-wide painting *Lawrence 1912—The Bread and Roses Strike* (pp. 26–27) to a private collector. "You can't do that," Carver responded. "That is the most important labor painting in America. I wish that *New York City*, *Family Supper*, your baseball paintings, and *Iceman Crucified* were all in public collections. But *Bread and Roses* is *our* painting, it represents *our* heritage. You can see it in union halls all across America, thousands of prints of that painting. Please don't sell it to a private collector."[1] Carver proposed that he raise the money to purchase the painting and donate it to a public building in Lawrence, Massachusetts.

Carver was very persuasive—and successful. He procured the funds for the painting and had it placed at the Lawrence Heritage State Park Visitors Center. That campaign led Carver to found Public Domain in 1988, a nonprofit organization dedicated to placing Fasanella paintings in public places. He left his job as a union organizer and replicated the fundraising model in cities throughout the country. He brought my father and his work into schools, union halls, and libraries. By May of 1991, *Family Supper* (p. 73) was permanently installed at the Ellis Island Immigration Museum. In 1995, *Subway Riders* (1950; pp. 112–113) was permanently installed in the subway station at 53rd Street and 5th Avenue, across from the Museum of Modern Art, through a joint effort by the American Folk Art Museum and the MTA's Arts for Transit program. Carver was successful in having another of the Lawrence mill series installed, *The Great Strike (IWW Textile Strike)* (pp. 86–87), this time in the Rayburn House Office Building in Washington, DC. But when the Republican Party gained control of the House of Representatives, which has its offices in the Rayburn House, the Committee on Education and Labor (now the Committee on Education and the Workforce) ordered the painting to be removed from the hearing room wall and sent to the AFL-CIO headquarters, where it hangs today.

At all Public Domain events, Carver and my parents sold and signed posters for ten to twenty dollars each to help raise funds to purchase paintings (though they gave them to any kid who wanted one). Public Domain raised nearly a million dollars and placed more than a dozen paintings in public locations throughout the country. The years my mother and father spent traveling with Carver were truly golden. Their marriage blossomed and they formed a newfound friendship.

The Public Domain project slowed down in the mid-1990s, and as my father aged into his eighties, the world he came to know as a younger man, as well as the one he envisioned as a radical intellectual, began to slip from his grasp. The end of the Cold War, the age of computers, the growth of big box stores, the replacement of small retailers with franchises, and the advent of a "postmodernist" and "post-consumer" culture put my father's grounded utopian vision squarely at odds with the world as it was evolving around him. But he never abandoned his profound faith in people and in the notion that the individual, by his or her very existence, has both the right to a fair share of what the community has to offer and to equitable treatment, and that each has a responsibility to help others and share one's own abilities with the community. But in the last decade of his life, he was out of his element in many ways, and this change is evident in his last canvases.

My father's last works convey his feeling of being dwarfed by the enormous responsibility of the artist. He had started using colors directly from the paint tube, no longer mixing the remarkable palette and complexity of color that distinguishes so much of his earlier work. He also lost his ability to paint in convincing multiple perspectives, and the images he created late in life are flattened out and simplified in ways similar to, but less creative than, his earliest paintings. Though the colors in his last paintings are far brighter and more hopeful than the works he produced just after the Depression, they are also less imaginative and skillful.

Throughout his last years he was still engaged with unionists as they worked through a strike at the New York *Daily News*. But after completing his tour with Carver, he spent much of his time sketching while sipping coffee at a replacement of his beloved luncheonettes—a fast food franchise. He also retreated to his world at home and spent countless hours enjoying company there or sketching with the family cat sitting beside him at the dining room table, delighting in the domestic setting my mother had built for him.

My father's legacy in paint is profound. In nearly three hundred paintings, whether he painted what he saw directly before him or delved into our political past to conjure where he saw our future, he painted the world in which he lived and the world in which he wished to live with a passion for people and for the beauty of the communities we are able to create.

1 Ron Carver, "The Public Domain Story," Smithsonian American Art Museum, 2014, http://americanart.si.edu/exhibitions/online/fasanella/Fasanella_Carver.pdf.

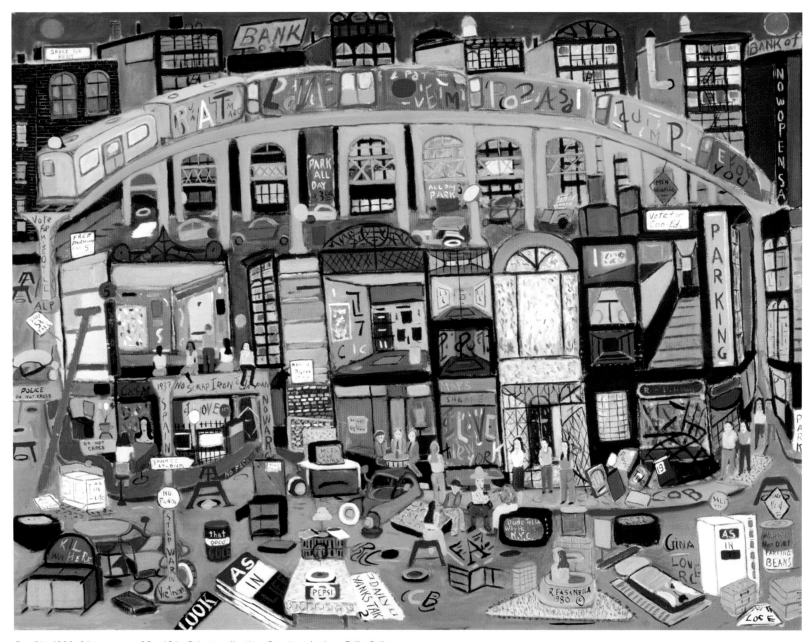

Fun City, 1980. Oil on canvas, 30 x 40 in. Private collection. Courtesy Andrew Edlin Gallery

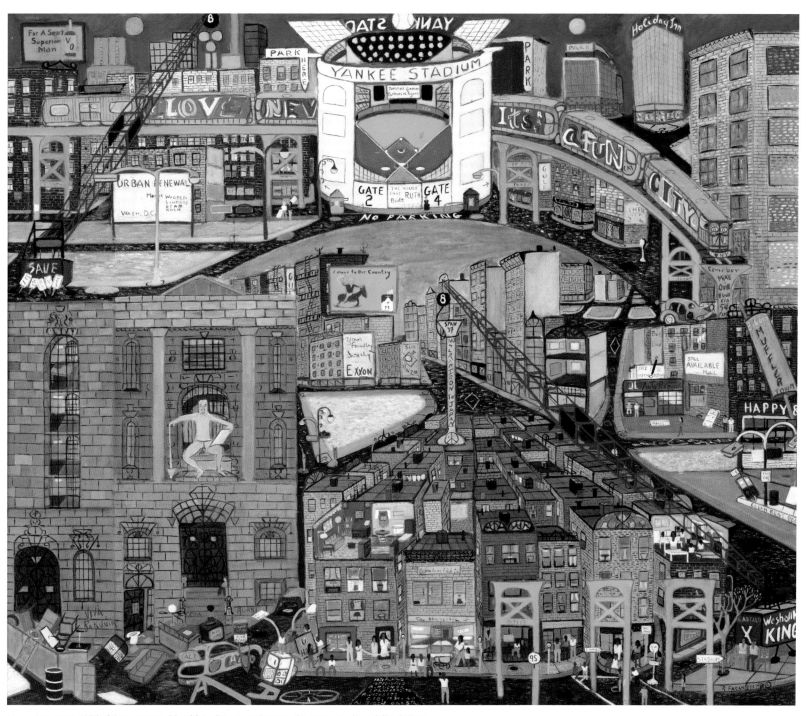

I Love New York, 1980. Oil on canvas, 52 x 60 in. Private collection. Courtesy Andrew Edlin Gallery

Subway Riders, 1950.
Oil on canvas, 28 x 60 in.
American Folk Art
Museum, New York.
Gift of Ralph and Eva
Fasanella, 1995.8.1

Daily News Strike Press Room, 1993. Oil on canvas, 24 x 30 in. Private collection. Courtesy Andrew Edlin Gallery

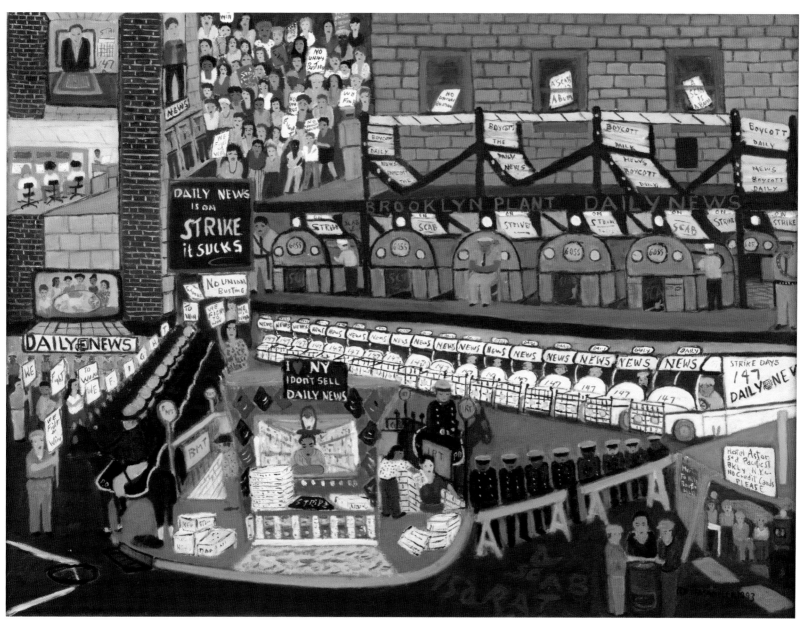

The Daily News Strike, 1993. Oil on canvas, 30 x 40 in. Private collection. Courtesy Andrew Edlin Gallery

At Home: 15 Chester Street, 1983. Oil on canvas, 27 x 31 in. Private collection. Courtesy Andrew Edlin Gallery

Afterword: Being Ralph's Son

Marc Fasanella

Growing up the child of a late-blooming, self-taught, social realist artist has been both a blessing and a curse. Since my father gained notoriety at the same time I began to develop my intellectual identity, being Ralph's son formed my *raison d'être*. Some of my earliest recollections are of sneaking down to his basement studio to watch him paint. The pungent odor of turpentine, which saturated his clothes and paint rags on his palette and taboret, and the smell of smoke, curling off the end of an unfiltered Lucky Strike or Camel cigarette that perpetually dangled from his lips, are still with me. He seemed intense but at the same time essentially relaxed, leaning forward off an old Windsor chair toward a stretched canvas set upon a wooden easel. He lit his studio with a bank of clip-on aluminum lamp hoods surrounding 150-watt incandescent bulbs. The studio was flooded with extremely bright but warm light. I was fortunate to have the opportunity to watch him, an inspired artist, pour his intellect, insight, emotion, and passion onto a canvas, to observe him experimenting with different versions of the same composition, illustrating light and depth and creating a unique image through the repeated application of a small brush loaded with oil paint. The feeling of that studio, with its smells and sounds, still inspires me and causes me to yearn for time to work in my own studio, to try my hand at many creative endeavors, to form spaces I am comfortable working in for long hours listening to inspiring music.

In each of our houses in Ardsley, New York, my father had a basement studio, but we lived the longest in the house set atop a large studio that my mother had made specifically for my father. The Chester Street home provided me with the most formative experiences of my young adulthood. Eva designed the studio to be set above grade on a sloping property facing the woods. She wanted my father to have a wood-paneled room filled with natural light flooding in from large windows looking out on the undeveloped land adjacent to our home. Knowing that he had a habit of working through the night, she installed the latest industrial fluorescent lights so he would have a brightly lit studio no matter what the hour. But within the first week following the studio's completion, he found he couldn't paint. After years of developing his method in darkened apartments or cramped basement spaces, he was accustomed to blocking out the outside world and any imagery that distracted him. We covered the paneling with white fabric, installed light-blocking shades, and constructed a rack of his familiar 150-watt bulbs.

Not too long after we moved into the Chester Street house, my father's work began to sell for decent prices and my parents agreed that he should retire and paint full time. I have vague memories of them in an earlier time, loading the family station wagon with artwork or tying paintings to the roof of the car to bring his work to art fairs. They would hang the canvases on a chain link fence with wire hooks and haggle with potential buyers for prices that would help pay the grocery bills but certainly not support a family. By the end of the 1970s his new studio complemented a new life dedicated to painting and attending art openings. As I entered adolescence I often accompanied Ralph on trips to his exhibitions and I came to understand the value of a life of intellectual pursuit and creative endeavor. We traveled to other artists' exhibitions at museums and commercial galleries and purchased beautifully illustrated monographs on Picasso, Van Gogh, Matisse, and Cézanne, among others. He began to call me "old man" and liked to run ideas past me. Occasionally we went to the old Fulton Fish Market or a baseball game, and he knew exactly where to find a wise guy who could arrange parking or a box seat for twenty bucks. At any art opening, he could hold forth impressively on any topic, having read volumes on European and American art history. He had met Hemingway, talked art with Ad Reinhardt, sung with Pete Seeger, discussed labor rights with Cesar Chavez, analyzed composition with Milton Glaser—his education was both by the book and from the street.

South Bronx Rebirth, 1995. Oil on canvas, 30 x 40 in. Private collection

There is something deeply engaging, wondrous, and invigorating in bearing witness to the life that informs a creative soul. You are drawn to experiencing the creative act as it unfolds; you become a participant and collaborator. I felt that way many times while watching my father at work. I also came to expect that at some point in my life I would find my own art form and pour my passion into it. It wasn't until his thirties that Ralph fell into painting as his vocation. I assumed the same would happen for me, and I tried my hand at many things: art, carpentry, graphic design, landscaping, stone masonry, percussion, and writing. I became skilled at the creative work I undertook, but no single occupation moved me the way my father was moved to paint. I am not an artist.

The arc of my father's career demonstrates that he produced his best paintings when he was most engaged in the political life of the world around him and the people who populated his environment. For everyday inspiration, Ralph remained a "city guy" drawn to inexpensive luncheonettes, where one could sit indefinitely for the price of a cup of coffee. He was most comfortable in a small, crowded place run by an owner just barely getting by. If he could smoke and talk baseball or politics with the regulars—conversing about the struggles of working-class life, the dignity of work on a factory floor, the need for a decent wage and time to read, play, and live a thoughtful life—he was in his element. He spoke his mind with urban eloquence (peppered with profanities) that could be hard on the ear, but faultless in its line of reasoning. His paintings are much the same. The perspective may be off, the colors unrealistic, the scale surreal, but the concepts he communicates are clear, startling in their insight, and powerful in their presentation.

In the 1980s he was having difficulty understanding how to indicate perspective in a painting. He had never felt the problem in the past; the power of his ideas had forced him to resolve the composition and move on. But this was happening in the Reagan era, and the world as he knew it was devolving. His thoughts were conflicting and disjointed and his paintings had become increasingly difficulty to produce. He knew I had studied mathematical perspective as part of my industrial arts teacher training, and he asked me to explain perspective to him. He had little use for the drafting table in his studio—one I still cherish—and he watched me as I used a T square, architects' scale, and triangle to work through demonstration drawings of one- and two-point perspective. He had a

pleasant, wry smile on his face as he observed my technical accuracy and the lifeless drawing I produced. I was proud of my work and asked him, "What do you think?" With true lightheartedness he responded, "Fuck you! I'm going to paint!" and went back to his canvas. A year or so later the same farce played out when he asked me about color theory. Throughout his oeuvre, the perspective is inventive and dynamic, the color intuited and powerfully evocative. He didn't need a teacher. He was studying on his own and what he had to say was much too important to be bogged down by lessons or technique.

I'm deeply thankful that I had so much time with my father, watching him study the work of other artists, listening to the discussions that informed concepts he developed in paintings, observing how he built up a composition, added details, and drew upon firsthand research to enrich a painting. Living alongside a self-taught intellectual who had achieved the freedom to pursue his muse—to think independently, experiment, fail, innovate, reconfigure, and recommit to his work in an endless dialogue with the world he inhabited—defined for me "the good life." Pursuing such a life has become a profound desire in me: a passion to live artfully and meaningfully, to share my thoughts, and to strive to improve the lives of others. Time with my father and his work enabled me to look through his images of an immigrant, early-industrial past and glean an understanding of a more communal, less consumerist life. It helped me understand how during extremely difficult times, such as the Great Depression, World War II, the McCarthy era, the civil rights movement, and the Vietnam War, progressive individuals have banded together. They peer through the darkness, support each other, and work to produce lasting social change.

In working on this book and looking at my father's paintings in the context of the twenty-first century, it became clear that he held out a fundamental hope for a universal human society. For many years I thought it was his critique of modern civilization that would earn him a noted place in the history of art. I now know that his positive spirit, his sanguine imagery, and his fundamental optimism were what gave him strength and imbued his work with a singular visual and intellectual depth of meaning.

Dobbs Ferry River View, 1975. Oil on canvas, 24 x 36 in. Collection of Marc Fasanella

Chronology

Paul S. D'Ambrosio

c. 1911 Ralph Fasanella's parents, Giuseppe (Joe) and Ginevra (Spagnoletti) Fasanella, immigrate to the United States with their son, Sabino (Sam), from Lavello, province of Apulia, Italy, and settle in the Fordham section of the Bronx, New York

1912 Fasanella's sister Angelina (Lea) Fasanella born

1913 Fasanella's brother Tomaso (Tom) Fasanella born

1914 September 10: Raphaele (Ralph) Fasanella born

1915 Fasanella's sister Theresa (Tess) Fasanella born

1916 Fasanella's brother Nicolo (Nick) Fasanella born

1919 Fasanella family moves to 173 Sullivan Street in Greenwich Village

1922–1924 Begins joining his father on his ice delivery route in Borough Park, Brooklyn

1925 Joe Fasanella sells his ice route and buys one in the East Bronx; family moves to 216th Street in the Bronx

April 6: Committed to the New York Catholic Protectory for petty crimes

December 12: Released to his parents

1927 March: Committed to the New York Catholic Protectory a second time

1928 June 20: Released to his parents

1929 January 10: Committed to the New York Catholic Protectory a third time; released to his parents midyear

Meets his mother's friend and mentor Pietro di Maddi, an Italian socialist and anti-fascist

1930–1932 Joins Workers' Alliance in response to a speaker in Union Square

Joins Young Communist League with Tess Fasanella and childhood friend Jim Dura

Lea Fasanella joins International Ladies' Garment Workers Union

Attends New York Workers School in Manhattan

1936 July: Spanish Civil War begins as General Francisco Franco launches a revolt against the socialist Spanish government

1937 Sails for France on board the *Ile de France* with about two hundred other volunteers

February 3: Mustered into service with the International Brigades at Albacete, Spain

April 12–July 4: Serves at the Madrid front as member of the First Regiment de Tren (a transport regiment) of the Fifth Army Corps of the Spanish Republican Army

July 6–28: Serves in heavy combat with the Regiment de Tren at Brunete

1938 January–February: Serves with the Regiment de Tren in the Battle of Teruel

April: Returns to International Brigades base at Albacete; temporarily assigned to antiaircraft unit

Summer: Returns to Regiment de Tren, where a new commissar attempts to institute tougher military procedures; assigned to artillery unit at the front

August: Attempts to air his concerns with International Brigades regarding suspicious activity on the part of his commissar, whom he thought might have been a fascist double agent; unable to reach the International Brigades commissar, boards a British ship out of Spain

October: Spanish Republic dismisses entire International Brigade

Organizes for State and County Municipal Workers Union during Elizabeth General Hospital strike in New Jersey

1938–1941 Organizing jobs include Local 670, Stationary Engineers and Building Service Employees; International Brotherhood of Teamsters; and the Bookkeepers and Stenographers Union

1939 April 1: Spanish Republican Army surrenders

1942 January 1: Joins the United Electrical, Radio and Machine Workers of America (UE) as field organizer; assigned to Sperry Gyroscope Company organizing drive in Brooklyn

December 22: Sperry workforce (numbering 25,000) votes by a three-to-one margin to join UE

1943 Takes part in organizing drive at Lukas-Herald Company in Indianapolis

October: Assigned to UE District #4 in the greater New York City area

1944 Working out of UE offices in Hastings-on-Hudson, New York, and Newark, New Jersey, takes part in successful organizing drives at Anaconda Wire and Cable Company and Western Electric

Reconnects with Eva Lazorek, a Western Electric employee whom he had met at Camp Unity (run by the Trade Union Unity League in upstate New York) in the early 1940s

During Western Electric campaign, experiences a curious sensation in his fingers

1945 Late summer: On vacation with friends in New Hampshire; tries his hand at drawing; soon begins painting

1946 Released from UE in the face of drastic budget cuts; works for his brothers Sam and Nick at their gas station in the Bronx; settles into a routine of working evenings, painting all night, and sleeping during the day

Lives in an apartment at corner of Grove and Bleecker Streets in Greenwich Village

December: Holds first solo gallery show, at 44th Street Gallery, New York

1947 February and March: Participates in a group exhibition at ACA Gallery (American Contemporary Art Gallery), New York, alongside Jacob Lawrence, Ben Shahn, and others

Paints *Pie in the Sky*

September: Holds solo exhibition at ACA Gallery that includes seventeen paintings

1948 Paints *May Day* and *Iceman Crucified #1*

1949 Runs for city council for the Twentieth District on the American Labor Party line, campaigning alongside Vito Marcantonio

1950 January: Holds solo exhibition at ACA Gallery

July 29: Marries Eva Lazorek; moves to apartment on 143rd Street in Manhattan

Paints *Local 65—Build Your Union* and *Subway Riders*

Finds work at the Morey Machine Shop; eventually placed in charge of the tool crib

1953 Laid off from Morey Machine Shop at end of Korean War; works in a variety of temporary jobs until going to work at his brother Nick's gas station in the Bronx

Paints *Morey Machine Shop* and *Sunday Afternoon*

June 19: Julius and Ethel Rosenberg executed at Sing Sing Prison, Ossining, New York; Fasanella marches with other demonstrators on East Broadway toward Rutgers Square

1954 Paints *Garden Party* and *Death of a Leader*

Spring: Holds solo exhibition *An Exhibition of Paintings by Ralph Fasanella* at Teachers' Union Center on 15th Street

August 9: Vito Marcantonio dies of a heart attack

Ginevra Fasanella dies in Arizona

Giuseppe (Joe) Fasanella returns permanently to Italy

1956 Paints *Iceman Crucified #3 (Passing of an Iceman)*

1957 Paints *Sandlot Game #2*, *New York City*, and *Festa*

April–May: Holds solo exhibition *Ralph Fasanella: Paintings* at James Gallery, 12th Street in Manhattan

1958 Paints *Iceman Crucified #4*

Moves with family to an apartment on Thieriot Avenue in the Bronx

Purchases Happy and Bud Service Station on 163rd Street in the South Bronx with two partners

Daughter, Gina Fasanella, born

1961 Paints *Lineup at the Protectory #2*

Joe Fasanella dies in Italy

1963 Paints *The Rosenbergs' Gray Day* and *McCarthy Press*

1964 Paints *American Tragedy* and *The Mad Sixties*

Son, Marcantonio (Marc) Fasanella, born

Moves with family to Ardsley, Westchester County, New York

1966 Produces, with Eva, color postcards of *American Tragedy* for distribution

September–October: Holds solo exhibition *Ralph Fasanella* at the Hudson River Museum, Yonkers, New York

1968 June: Holds solo exhibition at St. Augustine's Church on 165th Street in the Bronx, arranged by the Reverend Edler Hawkins

Paints *Happy and Bud's Service Station*

1971 Exhibits painting *Campaign—Lucky Corner* in group exhibition at the Hudson River Museum, Yonkers, New York; it is noticed by Frederick Fried, who introduces Fasanella to promoter Jay Hoffman

1972 Finishes *Dress Shop* and *Family Supper*

October 30: Appears on the cover of *New York* magazine with headline "This man pumps gas in the Bronx for a living. He may also be the best primitive painter since Grandma Moses."; cover story by Nicholas Pileggi titled "Portrait of the Artist as a Garage Attendant in the Bronx"

October–November: Holds major solo exhibition *Ralph Fasanella* at the American Foundation on Automation and Employment (Automation House), New York

November 14: *New York City* unveiled by Mayor John V. Lindsay at New York City Hall

Sells Happy & Bud Service Station and turns to painting full-time

1973 Eva and Ralph build split-level house with large studio in Ardsley, Westchester County, New York

May–June: Holds solo exhibition at Shaw-Rimmington Gallery, Toronto

September–October: Holds forty-seven-painting retrospective exhibition, *Fasanella's America*, at Xerox Corporation's Exhibit Center, Rochester, New York

Autumn: *Fasanella's City* (New York: Alfred A. Knopf), by Patrick Watson, published

1974 October: Holds solo exhibition *Ralph Fasanella* at Coe Kerr Gallery, New York

1975 October: Arrives in Lawrence, Massachusetts, determined to paint the 1912 Bread and Roses strike

1976 Paints *Mill Workers—Night Shift #2*; *Red Sky—Lower Pacific Mill*; *Mill Town—Weaving Department*; *Mill Workers—Night Shift #1*; and *Garden Street, Lawrence Mass.*

September–October: Holds solo exhibition *Ralph Fasanella* at the Hudson River Museum, Yonkers, New York

1977 Paints *Lawrence 1912—The Bread and Roses Strike* and *Mill Workers—Lower Pacific Mill*

October–November: Holds solo exhibition *Ralph Fasanella: Paintings and Drawings* at the Addison Gallery of American Art, Andover, Massachusetts

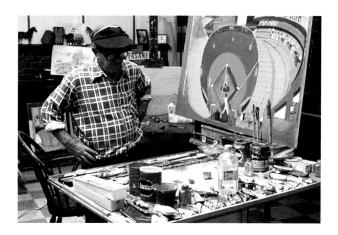

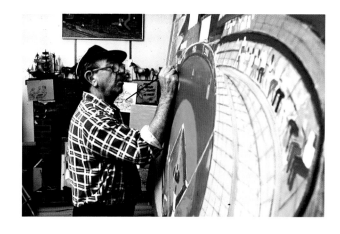

Ralph Fasanella at work

1978 Paints *The Great Strike (IWW Textile Strike)*

September–October: Debuts Lawrence paintings at Lawrence Public Library, Lawrence, Massachusetts

1979 September: Holds solo exhibition *Ralph Fasanella: His Work and His World* at Nardin Gallery, New York

October–November: Holds solo exhibition *Ralph Fasanella* at the Columbia Gallery, Chicago

1980 April–June: Holds solo exhibition *Ralph Fasanella: Lawrence 1912—The Bread and Roses Strike* at Gallery 1199, New York

Paints *Old Neighborhood* and *Organizing Committee—Dedicated to John L. Lewis*

1981 March: Holds solo exhibition *Ralph Fasanella: Recent Paintings* at Jay Johnson's America's Folk Heritage Gallery, New York

Paints *Night Game—Yankee Stadium* and *Night Game—'Tis a Bunt*

October: Holds solo exhibition *Ralph Fasanella: Greenwich Village Neighborhoods* at the Grey Art Gallery and Study Center, New York University, New York

1982 April–May: Holds solo exhibition *Ralph Fasanella: An Exhibition of Paintings Dedicated to Bill Cahn* at University of New Haven, West Haven, Connecticut

1983 April–December: Holds solo exhibition *Lest We Forget: The Paintings of Ralph Fasanella* at the Fenimore Art Museum, Cooperstown, New York

Paints *Gas Station Playground*

1984 April–May: Holds solo exhibition *Ralph Fasanella: Paintings* at Gallery Felicie, New York

1985 February–April: Holds solo exhibition *Hostos Celebrates Fasanella* at Hostos Community College, CUNY, Bronx, New York

Ron Carver, UE organizer in New Bedford, Massachusetts, sees Hostos exhibition and works to bring exhibition *Urban Visions* to the city

September–November: Holds major retrospective exhibition *Urban Visions: The Paintings of Ralph Fasanella* at the Herbert F. Johnson Museum of Art, Cornell University, Ithaca, New York; catalogue of the same name, by Suzette McAvoy and Paul S. D'Ambrosio, published

Autumn: Arrives in New Bedford, Massachusetts, to explore and paint as he had done in Lawrence

1986 Exhibition *Urban Visions* travels to the New York State Museum, Albany, New York; the New Bedford Whaling Museum, New Bedford, Massachusetts; the Tampa Museum of Art, Tampa, Florida; and the Museum of Art, Pennsylvania State University, University Park, Pennsylvania

Paints *Labor Education—New Bedford Union Hall*; Ron Carver successfully organizes $20,000 fundraising campaign for the city to purchase the painting and display it in the New Bedford City Hall

1987 May–June: Holds solo exhibition *Lawrence Revisited: The Paintings of Ralph Fasanella* at the Massachusetts College of Art, Boston

1988 May: Dedication of *Lawrence 1912—The Bread and Roses Strike* held in the Lawrence Heritage State Park Visitors Center, Massachusetts, following a successful $100,000 campaign led by Ron Carver

Ron Carver founds Public Domain, a nonprofit organization dedicated to placing Fasanella's paintings in public institutions

1989 Ron Carver forms the Northern California Labor Heritage Committee to purchase and place *Welcome Home, Boys* in the San Francisco Bay Area; painting later acquired for $53,000 and installed in the Oakland Public Library

Begins to frequent a Nathan's restaurant in Yonkers

Ron Carver organizes Maine Fasanella Tribute Committee and raises $40,000 to purchase *Red Sky—Lower Pacific Mill*

1990 Painting *Red Sky—Lower Pacific Mill* installed at Lewiston-Auburn College in Lewiston, Maine

November: Participates in the New York *Daily News* strike

1991 May: Painting *Family Supper* dedicated and installed at the Ellis Island Immigration Museum, the result of Ron Carver's successful yearlong drive

1992 Glen Pearcy produces *Fasanella*, an award-winning twenty-two-minute film centering on the *Family Supper* dedication

1993 Painting *The Great Strike (IWW Textile Strike)* dedicated and installed in the hearing room of the House Committee on Education and Labor, in the Rayburn House Office Building, Washington, DC, after being purchased for $150,000 by the Building and Construction Trades Department of the AFL-CIO

Paints *The Daily News Strike*

February–March: Holds solo exhibition *The Mad Sixties: Social Realist Paintings of the 1960s by Ralph Fasanella* at SUNY Westchester Community College, Valhalla, New York

Paints *Street of Dreams*, a commission for the cover of the May 31 Broadway Jubilee issue of the *New Yorker*

1994 Featured in *The Odyssey of the Abraham Lincoln Brigade* (Stanford University Press), by Peter N. Carroll

Paints *Nathan's—2 for $2*

1995 New Republican Chairman of the House Committee on Education and Labor orders *The Great Strike (IWW Textile Strike)* removed from the hearing room, causing a storm of protest in the media; painting installed in the AFL-CIO's Washington, DC, headquarters

Paints *South Bronx Rebirth* for the April issue of *Smithsonian* magazine

December: Painting *Subway Riders* installed in the 53rd Street–Fifth Avenue subway station, a donation from Ralph and Eva Fasanella to the American Folk Art Museum

1997 December 16: Dies at the age of 83; he is buried at Mount Hope Cemetery in Hastings-on-Hudson, New York; still on his easel, unfinished, is *Farewell, Comrade—The End of the Cold War*

1998 January: Memorial tribute held at the Martin Luther King Jr. Labor Center in New York

June–December: Solo exhibition *Baseball as America* held at the National Baseball Hall of Fame and Museum, Cooperstown, New York

2000 June–September: Solo exhibition *Fun City: Celebrating the Life of Ralph Fasanella* held at the Hudson River Museum, Yonkers, New York

2001 May: Paul S. D'Ambrosio completes doctoral dissertation "Ralph Fasanella: The Making of a Working-Class Artist," for Boston University's American and New England Studies Program

May–December: Major retrospective exhibition *Ralph Fasanella's America* held at the Fenimore Art Museum, Cooperstown, New York; catalogue of the same name by Paul S. D'Ambrosio published

June–July: Memorial exhibition *Ralph Fasanella: American Panorama* held at ACA Galleries, New York

2002 Exhibition *Ralph Fasanella's America* travels to the Mennello Museum of American Art, Orlando, Florida, and the New-York Historical Society, New York

2003 June–September: Exhibition *Ralph Fasanella's America* travels to the Ellis Island Immigration Museum, New York

2006 November 20: Eva Fasanella dies at the age of 86

December: Solo exhibition *Ralph Fasanella: Artist of the People* held at ACA Galleries, New York

2008 May: Solo exhibition *Ralph Fasanella: Passionate Visionary of New York* held at the Art League of Long Island, Dix Hills, New York

2013 May–July: Solo exhibition *Ralph Fasanella: A More Perfect Union* held at Andrew Edlin Gallery, New York

2014 April–June: Solo exhibition *Everyday Heroes: The Art of Ralph Fasanella* held at the Fenimore Art Museum, Cooperstown, New York

May–August: Solo exhibition *Ralph Fasanella: The Art of Social Engagement* held at AFL-CIO's Washington, DC, headquarters

May–August: Solo exhibition *Ralph Fasanella: Lest We Forget* held at the Smithsonian American Art Museum, Washington, DC

September–November: Solo exhibition *Ralph Fasanella: Lest We Forget* travels to the American Folk Art Museum, New York

Index of Artworks

Across the River, 1969, 67

Altar, 1947, 40

American Heritage, 1974, 10–11

American Tragedy, 1964, 20–21

At Home: 15 Chester Street, 1983, 116

Bench Workers (Morey's Machine Shop), 1954, 76–77

Cabin in the Woods, 1979, 93

Camden Maine, 1980, 97

Christopher Street #3, 1947, 42

Coffee Break, 1974, 107

Coney Island, 1965, 62 (detail), 64–65

Daily News Strike, The, 1993, 115

Daily News Strike Press Room, 1993, 114

Diner, 1980, 102

Dobbs Ferry—Railroad Tracks, 1975, 68

Dobbs Ferry River View, 1975, 120

Dobbs Ferry Road, 1967, 70

Dobbs Ferry Train Station, 1974, 103

Dress Shop, 1972, 78–79

Dress Shop Study, 1972, 75

Family Supper, 1972, 73

Farewell, Comrade—The End of the Cold War, 1992–1997, 28–29

Fun City, 1980, 110

Garden Party, 1954, 14

Gas Station Playground, 1983, 108

Grand Union, 1955, 46–47

Great Strike (IWW Textile Strike), The, 1978, 86–87

Grove Street: Fireplace, 1948, 37

Happy and Bud's Gas Station, 1968, 81

Happy and Bud's Office, 1968, 81

Happy and Bud's Service Station, 1968, 80

Honeymoon, Yellow Cabin, 1950, 45

Iceman Crucified #1, 1948, 12

Iceman Crucified #2, 1949, 55

Iceman Crucified #3 (Passing of an Iceman), 1956, 54

Iceman Crucified #4, 1958, 53

I Love New York, 1980, 111

Lawrence 1912—The Bread and Roses Strike, 1977, 6 (detail), 26–27

Lineup at the Protectory #2, 1961, 58–59

Love Goddess, 1964, 56 (detail), 60–61

Luncheonette, 1987, 104–105

Main Street: Dobbs Ferry, 1985, 99

Marc Fishing, 1978, 96

Marc in Backyard, 1974, 71

McCarthy Press, 1963, 18

Meeting at the Commons—Lawrence, 1912, 1977, 88–89

Mill Town—Weaving Department, 1976, 84

Mill Workers—Night Shift #1, 1976, 25

Mill Workers—Night Shift #2, 1976, 83

New York City, 1957, 50–51

Night Game—'Tis a Bunt, 1981, 24

Old Neighborhood, 1980, 100

Otero's House, 1975, 101

Other Side of the Tracks, 1947, 38

Peach Lake, 1977, 94–95

Pie in the Sky, 1947, 36

Ron's Rollin', 1985, 90–91

Rosenbergs' Gray Day, The, 1963, 16–17

Sam's Dream, 1948, 39

Sandlot Game #2, 1957, 48

Self-Portrait: Grove Street, 1954, frontispiece

S. Klein, 1949, 41

South Bronx Rebirth, 1995, 118

Subway Riders, 1950, 112–113

Sunday Afternoon, 1953, 49

Tony Pastor's Bar, 1947, 43

Wall Street, 1947, 34

Watergate, 1976, 22–23

Acknowledgments

In the creation of this book I have traveled extensively to view my father's paintings at museums. Sitting in front of the originals stirred many memories and revealed a flood of insights that looking at reproductions did not. The size of the canvases, the texture of the paint, the intimate details of each sub-composition in the paintings drew me into three-dimensional scenes that deeply affected my imagination and broadened my knowledge. My father's evolving use of color, scale, and emphasis are aspects of his work that only studying the originals with the intent of reading them as a visual text, as an entry in the story of art, allowed me to understand. I am deeply indebted to not only my father for leading me on this journey but to Thomas and Zoe Katherine Burke of Pomegranate Communications for enticing me to embark upon it, and to my wonderful wife, Anne Moyer, for accompanying me every step of the way.

Rob Battenfeld worked long hours with me as the estate archivist, developing a visual inventory and refining captions for the images. His remarkable commitment to this project was a source of great motivation for me. Richard Casabianca, both friend and intellectual associate, served often as an essential first reader, and his skill with language and discernment of meaning helped to make this a better book.

Two men view my father's work with as much passion and insight as my own: Ron Carver, director of the Labor Heritage Foundation's Fasanella Public Domain Project, and Paul D'Ambrosio, president and CEO of the New York State Historical Association and of the Fenimore Art Museum. Without their work on behalf of my father's oeuvre, this book would not have been possible.

Both Elizabeth Broun, former director of the Smithsonian American Art Museum and the Renwick Gallery, and Leslie Umberger, curator of folk and self-taught art at the Smithsonian American Art Museum, provided the initial inspiration for this book by launching the 2014 exhibition *Ralph Fasanella: Lest We Forget* at the Smithsonian American Art Museum and encouraging my writing about my father's work.

Gallerist Andrew Edlin and, specifically, his intrepid gallery manager, Jessica Caroline, were crucial to generating the images necessary for this book, as was Mimi Lester, the Rapaport Archivist at the American Folk Art Museum. Special thanks also go to Laura Vookles, chair of the Curatorial Department at the Hudson River Museum; Heather Lammers, director of collections and exhibitions at the McNay Art Museum; and Valérie Rousseau, curator of 20th-century and contemporary art, and Ann-Marie Reilly, chief registrar and director of exhibition production at the American Folk Art Museum.

Catherine Larkin, department head at the Digital Initiatives and Art Image Library at the Long Island University Post's B. Davis Schwartz Memorial Library, as well as her colleagues Jamani Hawkins-El and Cheng Zhang, provided essential assistance with generating images and captions for this book, as did Christina Milliman, curator of photography at the Fenimore Art Museum.

I would like to thank Krystal Eldridge for her insightful attention to important detail and helping me to craft a manuscript with much greater clarity, brevity, and historical accuracy. As a lifelong student of design and professor of graphic design, I awaited the layout of the copy and images with some trepidation, and I'm immensely gratified that Patrice Morris produced a book that is visually engaging, highly legible, and a pleasure to read.

I thank my cousin Marty Boles for sustaining the link between the American and Italian branches of the Fasanella family and providing a collective memory of the family history. I am also deeply appreciative of my sister Gina Mostrando, who graciously entrusted me with the stewardship of the artwork that composes my father's estate.

Last but certainly not least, I would like to acknowledge the support of my children, Mia and Michael, both remarkably intelligent and supportive young adults. I know that their grandfather's work holds an important place in their lives and has done much to make them the impassioned, empathetic spirits they are.

About the Authors

MARC FASANELLA has been a professor of art, architecture, and design for nearly thirty years. His work focuses on ecological aesthetics, permaculture-based education, and regenerative neighborhood design. Fasanella holds a MA in technology and industrial education and PhD in art and art education, both from New York University. He is a recipient of the Long Island University Trustees Award for Scholarly Achievement for his writing and design in the spirit of nineteenth-century luminary William Morris.

Raised by a progressive educator and a self-taught social realist painter, Fasanella was exposed to social justice and environmentalism at an early age. His parents were part of the nationwide struggle for civil rights, and as a youth he participated in the migrant farmworker movement led by Cesar Chavez and the environmental initiative Clearwater's Great Hudson River Revival, founded by Pete Seeger.

As an independent curator for cultural institutions in the New York metropolitan area, Fasanella has produced exhibitions featuring the work of notable artists such as George Rickey, Moses Soyer, Robert Gwathmey, David Burliuk, James McMullan, Richard Mayhew, and Milton Glaser, as well as his father, about whom he has written and lectured extensively.

In 2016 Fasanella launched the Ecological Culture Initiative, a community-based nonprofit that develops agroecology and permaculture-education programming in the community of Hampton Bays, New York.

Fasanella lives in Hampton Bays with his wife, Anne Moyer, and his two children, Mia and Michael.

LESLIE UMBERGER is curator of folk and self-taught art at the Smithsonian American Museum. Umberger has curated more than fifty exhibitions and lectured and published widely; her publications include *Something to Take My Place: The Art of Lonnie Holley* (2015); *Untitled: The Art of James Castle* (2014), and *Sublime Spaces & Visionary Worlds: Built Environments of Vernacular Artists* (2007).